Advance Praise for *Crossings*

"Finally, a book about cruising that is actually about friendship—sex and sensibility, desire as gateway to more connection, more critical engagement, more dreaming. Yes, *Crossings* rescues cruising from the drudgery of hyper-individualist masculinist posturing, invoking the sweet caress of ruined bodies against policing in all its forms. Guidebook, ode, invocation, and creative intervention—it's all here in this tender faggotry."

—Mattilda Bernstein Sycamore, author of *Touching the Art*

"Here is queer theory once again at the avant garde of sex, a supple crossing and blurring of two eloquent voices that edge the reader towards new plateaus of experience and pleasure. For any who fear that cruising has been gentrified, policed, or digitized out of existence, *Crossings* is here to disabuse you. With frank perversity, this highly original text is a highway to the danger zone. Once there, you may never want to come back."

—Tavia Nyong'o, author of *Black Apocalypse: Afrofuturism at the End of the World*

"*Crossings* is a thrilling, erudite study of cruising's pluralities, a deeply thought and deeply felt tribute to tricks, strangers, and lovers. Florêncio and Rosenfeld breathe life into the mutable history of their subject, their collective eye trained on the body in states of ecstasy, vulnerability, transition, and performance. Through an intimate dialogue between voices, this book left gaping my idea of sex and what it might yet be."

—Jack Parlett, author of *The Poetics of Cruising: Queer Visual Culture from Whitman to Grindr*

"*Crossings* is a rapturous testament to queer cruising and its potentialities for sex, friendship, and politics. As they entangle, throb, drip, and spread, Florêncio and Rosenfeld offer a queer theory that

is devoted to pleasure and love in the ruins of empire. Tender and intimate, horny and explicit, this book chronicles bodies that open, breathe in, and submit to the transformative powers of cruising as a practice of queer living. How could you not want to join in?"

—Zach Blas, assistant professor of visual studies at University of Toronto

"A truly remarkable work whose body exceeds any terms by which we might seek to constrain it. In their autotheoretical dialogue, and practice of merging, Florêncio and Rosenfeld tremble at the edges of various spaces, bodies, identities, desires, and temporalities, revealing in the process the pleasures and potentialities of erotic life in—or as—the ruins. Less a book than a constellation illuminating eroticism otherwise, *Crossings* invites us to remake the social by trusting what cruising may one day do."

—Sarah Ensor, author of *Queer Lasting: Ecologies of Care for a Dying World*

"Like the best experiences of cruising, this deliciously slutty, smutty book brings together two bodies alert and aroused to each other and generates a sticky and satisfying mess of anecdotes, insights, and revelations. Poetic and smart, raw and intelligent, filthy and sharp—this is a book that makes you want to head out and get your knees dirty."

—Glyn Davis, professor of film studies at University of St. Andrews, Scotland

"Florêncio and Rosenfeld share much of themselves in this lingering, wise, and enthralling analysis of the transformational potentials of cruising. Running through this dual memoir of temporary intimacies and their enduring impacts is a generous theory in the form of a colloquy—both intellectual and personal—about sex, gender, and finding oneself among others."

—David Getsy, author of *Queer Behavior: Scott Burton and Performance Art*

Crossings

Q+ Public

Series editors: E. G. Crichton, Jeffrey Escoffier (2018–2022)

Editorial Board

E. G. Crichton (chair), University of California Santa Cruz; co-founder of *OUT/LOOK* journal

Jeffrey Escoffier (co-chair 2018–2022), co-founder of *OUT/LOOK* journal

Shantel Gabrieal Buggs, Florida State University, Tallahassee

Julian Carter, California College of the Arts, San Francisco

Wilfredo Flores, University of North Carolina at Charlotte; Queering Medicine

Stephanie Hsu, Pace University, New York; Center for LGBTQ Studies (CLAGS); Q-Wave

Ajuan Mance, Mills College, Oakland, CA

Maya Manvi, San Francisco Museum of Modern Art

Don Romesburg, Sonoma State University, Rohnert Park, CA; GLBT Historical Society

Andrew Spieldenner, Cal State University San Marcos; MPact: Global Action for Gay Health & Rights; United States People Living with HIV Caucus

The Q+ Public books are a limited series of curated volumes, based on the seminal journal *OUT/LOOK: National Lesbian and Gay Quarterly*. *OUT/LOOK* was a political and cultural quarterly published out of San Francisco from 1988 to 1992. It was the first new publication to bring together lesbians and gay men after a decade or more of political and cultural separatism. It was consciously multigender and racially inclusive, addressed politics and culture, wrested with

controversial topics, and emphasized visual material along with scholarly and creative writing. *OUT/LOOK* built a bridge between academic inquiry and the broader community. Q+ Public promises to revive *OUT/LOOK*'s political and cultural agenda in a new format, and revitalize a queer public sphere to bring together academics, intellectuals, and artists to explore questions that urgently concern all LGBTQ+ communities.

For a complete list of titles in the series, please see the last page of the book.

Crossings

―

Creative Ecologies of Cruising

JOÃO FLORÊNCIO AND
LIZ ROSENFELD

FOREWORD BY GRACE LAVERY

Rutgers University Press
New Brunswick, Camden, and Newark, New Jersey
London and Oxford

Rutgers University Press is a department of Rutgers, The State University of New Jersey, one of the leading public research universities in the nation. By publishing worldwide, it furthers the University's mission of dedication to excellence in teaching, scholarship, research, and clinical care.

Library of Congress Cataloging-in-Publication Data

Names: Florêncio, João, author. | Rosenfeld, Liz, author.
Title: Crossings : creative ecologies of cruising /
João Florêncio, Liz Rosenfeld.
Description: New Brunswick, New Jersey : Rutgers University Press, [2025] |
Series: Q+ public | Includes bibliographical references.
Identifiers: LCCN 2024040372 | ISBN 9781978837546 (paperback) |
ISBN 9781978837553 (hardcover) | ISBN 9781978837560 (epub) |
ISBN 9781978837577 (pdf)
Subjects: LCSH: Cruising (Sexual behavior) | Sexual minorities—
Sexual behavior. | Gay men—Sexual behavior. | Public sex.
Classification: LCC HQ76.115 .F56 2025 |
DDC 306.77086/642—dc23/eng/20241212
LC record available at https://lccn.loc.gov/2024040372

A British Cataloging-in-Publication record for this book is available from the British Library.

Copyright © 2025 by João Florêncio and Liz Rosenfeld
All rights reserved
No part of this book may be reproduced or utilized in any form or by any means, electronic or mechanical, or by any information storage and retrieval system, without written permission from the publisher. Please contact Rutgers University Press, 106 Somerset Street, New Brunswick, NJ 08901. The only exception to this prohibition is "fair use" as defined by U.S. copyright law.

References to internet websites (URLs) were accurate at the time of writing. Neither the author nor Rutgers University Press is responsible for URLs that may have expired or changed since the manuscript was prepared.

♾ The paper used in this publication meets the requirements of the American National Standard for Information Sciences—Permanence of Paper for Printed Library Materials, ANSI Z39.48-1992.

rutgersuniversitypress.org

For tricks and lovers

Contents

List of Illustrations	xi
Series Introduction by E. G. Crichton	xiii
Foreword: Fucking Archives by Grace Lavery	xvii
Introduction	1
1. Space	23
2. Time	49
3. Matter	73
4. Breath	97
Acknowledgments	117
Notes	119
Bibliography	131

Illustrations

Heart, digital video, 2003, Liz Rosenfeld, Chicago. Black-and-white still of heart sonogram with some color gradients. 2

Heart, digital video, 2003, Liz Rosenfeld, Chicago. Black-and-white still of heart sonogram. 4

Liz/James/Stillholes, digital video, 2003/2017, Liz Rosenfeld, Chicago. 27

RUINS: Part I, live performance with mixed media, 2023, Liz Rosenfeld and an*dre neely, Berlin. 46

RUINS: Part I, live performance with mixed media, 2023, Liz Rosenfeld and an*dre neely, Berlin. 46

RUINS: Part I, live performance with mixed media, 2023, Liz Rosenfeld and an*dre neely, Berlin. 47

Tremble, HD video, 2022, Liz Rosenfeld, Berlin. 55

Tremble, HD video, 2022, Liz Rosenfeld, Berlin. 57

Tremble, HD video, 2022, Liz Rosenfeld, Berlin. 65

The Artist Lays on the Fuck Tree, photo, Hampstead Heath, London, 2017. 76

Tremble, HD video, 2022, Liz Rosenfeld, Berlin. 79

Tremble, HD video, 2022, Liz Rosenfeld, Berlin. 80

All My Holes #2, drawing, ink and graphite on transparent paper, A3 297×420 mm, 2021, Liz Rosenfeld, Iceland. 93

All My Holes #1, drawing, ink and graphite on transparent paper, A3 297×420 mm, 2021, Liz Rosenfeld, Iceland. 94

Glory Duet, drawing, ink and graphite on transparent paper, 2021, A4 210×297 mm, 2021, Liz Rosenfeld, Iceland. 106

FUCK TREE, Super 8 film, 2017, Liz Rosenfeld, London. 110

I Live in a House with a Door, performance and mixed media, 2022, Liz Rosenfeld, ANTI— Contemporary Art Festival, Kuopio, Finland. 114

Series Introduction

Q+ Public is a series of small thematic books in which leading scholars, artists, community leaders, activists, independent writers, and thinkers engage in critical reflection on contemporary LGBTQ+ political, social, and cultural issues.

Q+ Public is about elevating the challenges of thinking about gender, sex, and sexuality across complex and diverse identities to offer a forum for public dialogue.

Q+ Public is an outgrowth, after a long hibernation, of *OUT/LOOK Lesbian and Gay Quarterly*, a pioneering political and cultural journal that sparked intense national debate over the five years it was published, 1988 to 1992. As an early (and incomplete) model of intersectional inclusion, *OUT/LOOK* was the first publication since the early 1970s to bring together lesbians and gay men after years of separate movements. The visual and written content of *OUT/LOOK* addressed complex gender roles (with a blind spot about transgender issues), was racially diverse, embraced political and cultural topics that were controversial or had not yet been articulated, and emphasized visual art along with scholarly and creative writing. In a period when LGBTQ+ studies and queer theory were coalescing but not yet

xiii

established, *OUT/LOOK* built a bridge between academic inquiry and broader community.

The Q+ Public book series was initially conceived by E. G. Crichton and Jeffrey Escoffier, two of the six founders of *OUT/LOOK*. They brought together a diverse and highly qualified editorial collective. The plan is to issue several books a year in which engaged research, art, and critical reflection address difficult and challenging topics.

The idea of a complicated and radical queer public has long been part of the vision and writing of Jeffrey Escoffier. Sadly, Jeffrey died unexpectedly in May 2022 at age 79, leaving behind Q+ Public, as well as several other publishing projects. Prolific, full of ideas and vision to the end, he is widely missed. The Q+ Public collective continues this work in his honor.

Each book in the Q+ Public series finds a way to dive into the deep nuances and discomforts of a topic. Each book features multiple points of view, strong art, and a strong editorial concept.

Crossings: Creative Ecologies of Cruising is a book about queer cruising. Cruising is explored not only as the search for sex, but also as a creative methodology of the erotic that decenters space, time, identities, and the materiality of bodies, opening them all to new constellations of being and to pleasures unknown. Drawing in part from histories of gay male cruising, the book stages a creative autotheoretical dialogue between a queer artist and a queer academic reminiscing about and thinking through their cruising lives. The result is an erotic hybrid form hovering between artist book and scholarly work, between manifesto and sex memoir. The voices of each author, merged together

into one, invite the reader to inhabit the erotic spacetime between self and other, the familiar and the strange, desire and pleasure, climax and release—the spaces and temporalities of cruising itself.

E. G. Crichton

Foreword

Fucking Archives

Where is the archive of sex? Both palimpsest and carceral apparatus, the case study has become, increasingly, the instinctive answer to that question.[1] The case study can be poignant, misguided, symptomatic-despite-itself, and in some situations—when climate-controlled, solitary, and special—even sexy. One does not want to hypothesize that nobody has ever masturbated to memories of themselves flicking through the Kinsey archive, or *in* that archive, or in settings resembling that archive: book snakes, yellow tissue paper disintegrating from the oil of one's body, thimbles on fingers, an immersive hush, a beady-eyed surveillance official (perhaps clad, like a NASA ground control officer, in tight jeans and black-rimmed specs). The archive of case studies makes the private public, by opening the private lives of the citizenry to anyone who wants to stop by; and it then privatizes the experience once more: a material text, unlike a digital one, can really only be scanned by one pair of eyes at a time.

There are other archives of sex, nested in equally compromised domains: some are phenomenological (the "spank bank"); some are encyclopedic (PornHub); some are

institutional (Clapham Common); some are diagrammatic (Alice's map in *The L Word*); some are held by community (the Transgender Oral History Project). Others. None of these exist in private or in public: like sex, even the most solitary version of which takes place in a relational matrix, the sexual archive prompts its visitors to skip between visibility and seclusion, whether by deploying the alibi of professional interest, the steadying fiction of "incognito mode," or another obliquity. Flirting. Given the ways in which the regime of privacy has become, in the last few decades, one of the primary features of gay liberalism challenged by queer theory, we might ask why our archival range remains so narrow. Lauren Berlant and Michael Warner's crucial essay "Sex in Public" *theorizes* the prior publicity of sex—at most, one could say that the essay *postulates* sex in public, in the Kantian sense ("a *theoretical* proposition, though one not demonstrable as such, insofar as it is attached inseparably to an a priori unconditionally valid *practical* law").[2] But the essay does not refer to sex in public as that phrase initially hits the eye. If anything, the essay's project is seclusionary: by showing that even the most heteronormative hump depends upon the enclosure of space presumptively designated as public, Berlant and Warner derive a rationale for keeping the str8s and ethnographers away from Cherry Grove. Warner went on to develop this idea in greater detail as the "counterpublic."[3]

In his introduction to *Porn Archives*, the psychoanalytic critic Tim Dean explores the ruinous quality of the book's subject: "pornography" designated first an archaeological term of art, referring to those works recovered from Pompeii and Herculaneum deemed unfit for public display.[4] As Dean delicately argues, however, one person's sequestration is another's preservation. Cruising can take place in the ruins—even in those particular ruins, where Wilhelm

Jensen set his novel *Gradiva* (1902), concerning a young archaeologist trying to find the girl of his dreams.[5] The dream depicted a young woman, seemingly a figure the dreamer has observed in an ancient bas-relief, walking a few steps ahead of him, as Vesuvius erupts, drowning dreamer and walker in ash. Dreamer then travels to Pompeii, and sees the girl from his dream there, walking a little ahead as in the dream—he follows her, hails her in Latin, is met with a brusque reply in his native German, and then loses track of her. As the archaeologist tries to figure out which, if any, of the foregoing events had been delusive, he realizes that the girl is a childhood friend of his, on whom he had been sexually fixated to the point of complete memory-foreclosure, who eventually rouses him out of his paranoid stupor, and he follows her footsteps out of the ruins.

Freud's essay on Jensen's *Gradiva*—one of his longest and most substantial treatments of a single literary work, almost as long as the (slim) novella itself—is pleased to find in the story an illustration of the psychoanalytic mechanism of repression.[6] Infantile eroticism (which took the girl, Zoe Bertgang, as its object) has been repressed, leading to a neurotic displacement of the sexual aim onto the bas-relief. When he sees Zoe in Pompeii, she performs a kind of lay psychoanalysis upon him, and when she agrees to walk a little ahead of him as they progress out of the ruins (a request he articulates "mit einem eigenthümlichen Klang der Stimme [with a queer tone in his voice]"), Freud pronounces his repressed fixation now successfully sublimated into a foot fetish. Thence, *Gradiva* serves psychoanalysis as the typifying example of "cure by seduction," where the seducer and analyst have merged into a single figure, who walks ahead of the seduced/patient, and enables decathectic relief through erotic displacement. Freud's reading of *Gradiva* is certainly

in line with Jensen's intentions for the book, as we know from correspondence between the two. But it declines to explain the strangest element of the story, which is that the archaeologist only traveled to Pompeii under instruction from a dream. Either Zoe happened to be there by sheer coincidence, or else he had repressed knowledge Zoe would be there, and the resemblance between her and the bas-relief was the coincidence. Neither coincidence is easily resolved.

To be seduced, to be led, to be hailed in one language and to reply in another: these are fixtures of what João Florêncio and Liz Rosenfeld assemble as the archive of cruising. Of *their* cruising, together and apart; of *ours*, past and present; of *everyone's*, real and imaginary. In this sweaty, bull-headed book, the authors dispense with the euphemisms and delusions that cloud Freud's judgment, and ours. Here is a discourse on sex—not on sexuality, but on sex—that slips a knot between habit and surprise, immediacy and anticipation. To read this book is to ask João and Liz to walk a few steps ahead of us, while we watch them making themselves, gripping themselves, girding themselves. It is to accede with ambivalence, defiance, and zeal to the seduction of one's analyst. They have assembled for us a new archaeology, in the ruins of the gay liberalism that collapses around us on all sides, smothered in ash and dust. I would follow this book anywhere, and I am sure that I am not alone.

Grace Lavery

Grace Lavery (she/her) is a writer and academic. She is regularly called a pervert by both people that like her and people who do not. She has published three scholarly books—*Quaint, Exquisite: Victorian Aesthetics and the Idea of Japan*, which won the North American Victorian Studies

Association's Best Book of the Year Prize; *Pleasure and Efficacy: Of Pen Names, Cover Versions, and Other Trans Techniques*, which was shortlisted for a Critic's Choice Award; *Closures: Heterosexuality and the American Sitcom*—and one memoir: *Please Miss: A Heartbreaking Work of Staggering Penis*. Her research focuses on the frangible line between sexual embodiment and interpretive reasoning.

Crossings

Introduction

Since our mutual friend Johanna first introduced us via email in 2017, we've been cruising each other in different ways. João had just finished his doctoral studies and moved out of London for a job in the southwest of England. Liz was in Berlin but also often in London. Liz was making new work about holes; João had written a PhD about performance and queerness beyond the human. Both of us were interested in ecology, broadly understood as the study of how bodies relate to one another and to the spaces they occupy, however ephemerally. Ours was and still is a particularly queer interest in ecology, especially since we are both interested in ecologies sustained by desire and pleasure, that is to say, by life.

Life, however, kept on preventing us from meeting . . . always in different cities, never in the same place at the same time. Work, life, expensive British trains, research targets, grant applications, rehearsals, projects old and new—that kind of stuff—all got in the way. We eventually did meet in person, finally, years later in Berlin. A coffee off Kottbusser Damm turned into hours of laughter, bitching about the art world and academia, moaning about various situations, and quite a lot of talking about sex, and about cruising. Somehow, we both felt a deep love for faggot history and culture, while at the same time being—in different and important

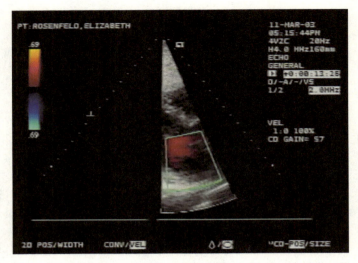

Heart, digital video, 2003, Liz Rosenfeld, Chicago. Black-and-white still of heart sonogram with some color gradients. Courtesy of the artist.

ways—very disenchanted by it. We bonded quite deeply around the ways in which we both identified as faggots, honoring the political history of the term as it had been appropriated and subverted by the 1970s homosexual movement. Yet, we wished faggot culture would one day awaken to its potentiality beyond the usual kinds of gay microfascisms we were seeing, and still see, in most places we love—and love to hate. The years passed, but the bonding continued across different collaborations, exchanges, encounters; days and nights spent together before drifting apart; back to other friends, partners, lovers; back to work; back to different cities; back to rehearsals, research targets, classrooms, university bureaucracy, galleries, theatres, performance spaces, institutions old and new.

One of Liz's early video works, *Heart*, first grabbed João's attention, and keeps on grabbing it every single time

he watches it, despite Liz having grown away from that work, a piece they produced in 2003 while studying for their MFA. *Heart*, a haunting and extremely sexy story of Liz's attempts to infiltrate gay men's cruising spaces, is told by Liz's disembodied voice against the video backdrop of a scan of their heart:

> Sometimes, when I'm cruising boys on the street, or on the subway, I secretly pretend I'm in a bathhouse. I'm wandering through steamy rooms, guys fucking in dark corners, hands coming at me, straight out of some kind of nowhere of place, reaching for my towel, looking for my hard dick. But I shoo them away because I'm convinced I'm gonna find the perfect boy, the one who lets me pull his hair while I'm fucking him up against the scorching sauna wall, pressed so hard against the wall that his tits burn, his nipples turn red, but still he doesn't tell me to stop.

The piece goes on for just under eight minutes, in what is a steamy detailed account of a fantasized sexual encounter, one in which Liz would be just another body fucking among all the other bodies fucking.

Heart is a work we often talk about, and one that triggered some of our earliest conversations about cruising, its potential as an ethical and political laboratory, and the shortcomings of its extant iterations: the microfascisms, the crystallizations of processes of becoming into hardened forms of being, the segregations, the gatekeeping, the fear one may not know how to fuck a body that doesn't look like the bodies one has fucked before. Not that one *must* fuck them. Only that, at the level of the body just like at the level of most other things, familiarity breeds contempt for the unfamiliar.

Introduction 3

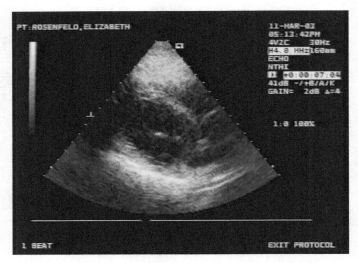

Heart, digital video, 2003, Liz Rosenfeld, Chicago. Black-and-white still of heart sonogram. Courtesy of the artist.

That, in turn, betrays the potential we both see in cruising understood as a formation of space, time, and flesh where the porosity of self to other, of the familiar to the strange, can produce constellations of affect, desire, erotic kinship, and pleasure capable of carrying us away from the miasma of the present—to carry us away from all the ways in which we told ourselves that certain things fit in certain places, that certain bodies belong here, that others belong there. Cruising, after all, is always about transgressing borders but never only for the thrill of transgression. Rather, it is about transgressing borders to creatively produce new kinds of multitudes. This book is the product of our encounters with one another, of our conversations about sex and cruising, of João's fascination with how cruising is approached and deployed in Liz's artistic work, and of our own memories of inhabiting those spaces where bodies meet and sometimes

fuck one another, always happy to be there, but also wishing many of those bodies could more fully grow into the spaces we thought they had the potential to become.

On Cruising

It is difficult to know the origins of cruising. Etymologically derived from the Latin *crux* ("cross")—both a noun and verb implying devotion but also intersections, junctions, crossings—cruising is often associated with modern urban environments. As a queer subcultural practice of wandering around public places in search of casual sexual encounters, cruising can nonetheless be said to have existed ever since people who weren't captured by hegemonic sex-gender systems found themselves seeking sexual encounters outside of sanctioned regimes—and spaces—of pleasure, intercourse, or kinship. While mostly associated with cis gay men, and often written about as a subset of modern bourgeois (male) flânerie, scholars have shown that cruising spaces were often populated with a much wider variety of pleasure-seeking bodies joined together in their shared sexual deviance.[1]

While, according to historian George Chauncey, the term "cruise" was used by men seeking casual encounters with other men in the parks and streets of New York City as early as the 1920s, historical records—chiefly police and court documents—show that the practice is indeed much older.[2] Michael Rocke, another historian, writing about sodomy in Renaissance Florence, notes how homosexual encounters created a particular sexual geography of the Italian city that is widely mythologized as the node that connected classical and modern European cultures.

It is amusing to realize that public sodomy was widespread in the very city that still lives off its purported status

as the cradle of early modern European art and culture. Thanks to the records of the Ufficio della Notte (Office of the Night)—the judiciary body set up by the Republic of Florence in 1432 with the sole purpose of finding and prosecuting sodomy—we know that at least seventeen thousand men were accused of sodomy at least once, and approximately three thousand were convicted between 1432 and 1502 in a city of around forty thousand people. The numbers are staggering; sodomy was truly "part of the whole fabric of Florentine society."[3] Beyond confirming how popular sodomy was in Florence, those very records also "reveal a rough topography of sodomitical activity" that would take place in four main kinds of spaces: public streets and other open areas, private homes, *botteghe* or workshops, and taverns.[4] Rocke writes:

> Many men and boys sodomized in fields outside the city
> gates or in the extensive private or conventual gardens
> that ringed the congested city center out to the walls. But
> most open-air encounters occurred in the ancient heart of
> the city. The narrow, poorly lighted streets; the densely
> packed shops and houses, with their covered doorways,
> overhanging upper stories, and supporting arches; the many
> stables and storage sheds—all afforded secluded niches for
> furtive trysts. Sex in public had its risks, since watchmen
> patrolled the streets after curfew, but surprisingly few
> sodomites were caught in the act by these patrols.[5]

These were places that, in Renaissance Florence, sodomites shared with other sexual and gender outlaws like female sex workers or *meretrici*, as they were labeled. And both demographics had to be controlled by a city power whose interests rested less on the eradication of either one of them than

on the regulation of both. Through organizations like the Ufficio della Notte that controlled sodomy (1432–1502), and the Ufficio dell'Onestà (Office of Decency) overseeing prostitution (1403–1680), Florence was able not only to regulate cross-class social interactions and protect the sanctioned kinship institutions needed for the social reproduction of the state and of private wealth accumulation, but also to ensure a regular stream of income through identifying and taxing prostitutes, and identifying and charging sodomites with the payment of fines.[6] What was germinating in early modern Florence were the seeds of what would become the disciplinary apparatus of later modern states that depended on the development of sophisticated mechanisms for the administration of sexual outlaws, mechanisms that relied on a constant stream of information, confessions, accusations, official registers, and public discourse about sexuality and gender roles. Importantly, these were the very same systems of knowledge that came to define and ensure the sustainability of the modern bourgeois understanding of what is public and what should remain private.

Private Desires, Public Consummations

Defining and policing the public/private divide has been central to modern state power, but the distinction is much older than the political institutions of today. One of the possible origins of the split dates to ancient Greece and the distinction made by the likes of Plato and Aristotle between *oikos*—the private home—and *polis*—the public sphere where matters of concern for the state would be discussed and deliberated upon. In post-Enlightenment modern nation-states, the divide becomes bureaucratized as a means to, in the words of Ann Davis, "assign specific decision-making

authority and procedures, and ultimately to privilege and prioritize some types of institutions and corporations relative to others."[7] Because modern citizens are understood to be members of "a distinct collective, with a common mission, symbolic representation, perpetual existence, with collective decision-making processes, and assignment of specific roles," the public/private divide emerged as a central mechanism guiding the spatialization and distribution of resources, wealth, and bodies in the modern nation-state.[8] This, therefore, worked to ensure not only smooth flows of wealth down patriarchal kinship lines—for instance, from father to son—but also to regulate the relationships within the private institution of the family as property relations established along gendered lines and formalized in marriage contracts and inheritance laws. This, in turn, ensured that women, subjected to the authority of their husbands, continued to carry out reproductive and care work to guarantee the longevity of the state and of the workforce. For his part, the husband, subjected to the authority of his boss, would continue to work at his job on behalf of wealth production and accumulation. The family and the firm constituted the two core institutions of the private realm. With human reproduction and care work outsourced to the family, and commodity and wealth production outsourced to the private firm, the state ensured its own social reproduction while tending to increasingly restrict its role to one of regulation and macroeconomic administration. In Davis's words: "The home became the location of leisure and commodity consumption, where white middle-class women's unpaid labor sustained the image of the household. . . . The liberal nation-state was then founded on universal laws in the public sphere, but [with] particular exceptions in the private sphere."[9] The universal laws Davis refers to are the principles of equality,

freedom, and cosmopolitanism that guided the mythology of the public sphere as the place where citizens come together as equals to discuss matters of shared concern, as famously theorized by German philosopher Jürgen Habermas.[10] Yet, while those principles of equality, freedom, and cosmopolitanism were idealized as universal, they were nonetheless restricted to only a section of the population, those privileged with full citizenship.[11] Therefore, participation in the public life of the liberal state has either been historically restricted to certain sections of the population or otherwise conditioned by a series of imperatives concerning what does and does not belong in public.[12]

When Carol Hanisch wrote "The Personal Is Political" in 1970, she was interested in how the discovery of shared private experiences of oppression and suffering constituted a pathway to feminist consciousness-raising.[13] In order to become a collective political actor, women had to first realize that the violence, trauma, and other negative affects they experienced in their personal lives were, in fact, what united each one of them with every other woman. "I'm every woman" was precisely what Chaka Khan sang in 1978, only for Whitney Houston to sing it again in 1992. Despite the fourteen years separating the release of both songs, both Chaka and Whitney were every woman. Just like Beyoncé wanting a ring on it, Piaf regretting nothing, Taylor shaking it off, or Britney needing her baby; just like Jacinda crying in Parliament, Meghan struggling with her husband's royal family, or Naomi taking a break from tennis to look after her mental health, every woman—we've been told—is every woman, just like "a rose is a rose is a rose," in Gertrude Stein's poetic delving into the problem of universals. What connects them all is womanhood as an affective genre, an

intimate public constituted through a mode of address defined by overshared sentimentality and complaint, as Lauren Berlant has noted. In that context, contemporary womanhood is produced through what Berlant identified as the "economies of suffering" central to mass capitalist aesthetics.[14] Whether through women's TV, advice columns, or the algorithmic capitalization of trauma narratives on social media platforms—where, as Sarah Schulman noted, conflict is conflated with abuse—victimhood, conveyed through personal narrative, has become the contemporary structure of feeling par excellence.[15]

Yet, while part of a historical continuum, there are important differences between the radical feminism of Hanisch's strategies for female consciousness-raising by means of making public the burdens of private life and the ambivalent intimate publics of the twentieth- and twenty-first-century media landscapes discussed by Berlant and understood as "juxtapolitical"—that is, as besides, next to, or in proximity to politics and its formal institutions.[16] Those are important differences that can be illuminated and grasped by drawing from related bourgeois dyads such as seriousness and playfulness, politics and entertainment, tastefulness and tastelessness, or decent and obscene. On the one hand, the radical feminist statement "the personal is political" implies a set of political values on behalf of which the private is allowed to be temporarily made public. The private is only brought into the public sphere because it is there, in the public sphere, that the private is always regulated and sanctioned as private, thereby granting its subjects intimate citizenship. It is precisely there that we locate the radical feminism of Hanisch and the defining statement of second-wave feminism that "the personal is political." The personal is political only and if it can be translated into or refracted

10 Crossings

through a series of public values concerning humanist bourgeois ideas of equality, autonomy, or morality. We would go as far as saying—arguably in a more problematic register—that, to the second-wavers, the personal is political as long as it is the handmaiden of public morals; the personal is political as long as it is serious. Of course, the denial of autonomy to women has been a serious and important issue at least since Immanuel Kant claimed that "enlightenment is *man*'s emergence from *his* self-incurred immaturity."[17] But what if one could speak of the private dynamics of sexuality and of its public manifestations as something that ought not to be merely framed by "serious"—by which we mean "legitimate" and "worthy"—bourgeois discourses of emancipation, of the proper, the healthy, the moral, the political, for sex and sexuality will always-already exceed each and every one of the terms through which we try to frame them, to discipline them?

This is not just an issue with second-wave feminism or its legacies. The history of homosexual activism itself has unfolded along the same lines, especially after the onset of the AIDS epidemic in the 1980s. In what Benjamin Shepard has called "the queer/gay assimilationist split" in the U.S. homosexual movement, the aftermath of AIDS saw homosexuals moving from being a proudly perverse and promiscuous movement that placed the joy of nonnormative sex at the center of its political and social project to becoming an institutionalized movement of "good gays" seeking nothing but assimilation into the liberal state through intimate citizenship.[18] Giving his article the straightforward subtitle "The Suits vs. the Sluts," Shepard notes that the movement went from the Gay Liberation Front's slogan "Perverts of the World Unite!" to the likes of Larry Kramer and Andrew Sullivan blaming unbridled desire for all the pains suffered

Introduction 11

by homosexuals, and calling for gay men to grow up towards some idealized state of maturity that replicated the very ideal of male autonomy and citizenship embodied by the very straight heteropatriarchal state that had excluded them but to which they nonetheless begged for inclusion.[19]

Even after civil rights movements, feminism, and homosexual and trans activism, our public sphere and its institutions continue to be dominated by a particular demographic, while gender and racialized minorities are still very much absent or tokenistically represented. Sexual minorities, on the other hand, are allowed to participate, but only if they leave their sexuality and their passions at home, where they belong. The most recent symptoms of those very logics are the ongoing public debates on the presence of proud kinksters at Pride parades, anti-sex discourse among growing numbers of people, moral panics about drag queens reading stories to children, and the abandonment of sexual liberation ideology and of sex itself as part and parcel of a queer politics and queer thought on behalf of a popular LGBTQ+ discourse that privileges static understandings of identity over the radical transformative potential of desire, pleasure, and sexually animated flesh.[20] Sexuality is indeed meant to stay contained at home, as something that belongs only to private life, even while it keeps on being regulated in public discourse. In the words of Ken Plummer:

> All of this, of course, means that one cannot simply speak about an intimate zone that is cut off from the public, the social, and the political (any more than there can be a completely public zone cut off from any aspects of the personal). Intimate citizenship refers to all those areas of life that appear to be personal but that are in effect connected to, structured by, or regulated through the

public sphere. They are rarely, if ever, simply a matter of the personal. . . .

Again, what we are talking about here are public discourses on the choices that cluster around personal life, which are themselves not just personal but political and social. We are no longer talking about the separation of private and public spheres, but of continuums, pathways, and intersections between them.[21]

As a sex-cultural formation that wholly refuses a separation between the public and the private, instead inhabiting the space right where the two spheres become porous to one another, cruising is a set of practices, codes, and meanings that embodies, rethinks, and contests some of the ideas sustaining modern social roles and institutions, rituals, sociability, ethics, kinship . . . life itself. If the public/private divide is to be understood as a spatialization of life, it is in the geographies of cruising that one finds the ensuing spaces collapsing into one another.

Cruising Geographies

In *The Practice of Everyday Life*, Michel de Certeau famously developed a theory of walking understood as a creative means to produce space. According to de Certeau, the city, as idealized by the bird's-eye view of urban planners, has been predicated on a rationalization of space through cartographical projections that flatten the particular on behalf of the universal. The city, he writes, "provides a way of conceiving and constructing space on the basis of a finite number of stable, isolatable, and interconnected properties." As a model of rational organization of space, it "must repress all the physical, mental and political pollutions that would

compromise it."[22] It is only thanks to this kind of thinking that very specific spatial imaginaries are not only produced but also communicable whenever we say "London," "New York," "Paris," "Berlin," "Rio," "Beirut," "Mumbai," "Beijing," or whichever other cities for which we hold mental maps, whether or not we have been in them, let alone lived in them. The city plan takes over and flattens the differences within the city itself on behalf of its public picture, a collective public mental place.

Yet, for de Certeau, the city is also a practice that escapes—that exceeds—the supposedly unrestricted godlike vision of urban planners and their plane projections:

> The ordinary practitioners of the city live "down below," below the thresholds at which visibility begins. They walk—an elementary form of this experience of the city; they are walkers, *Wandersmänner*, whose bodies follow the thick and thins of an urban "text" they write without being able to read it. These practitioners make use of spaces that cannot be seen; their knowledge of them is as blind as that of lovers in each other's arms. The paths that correspond in this intertwining, unrecognized poems in which each body is an element signed by many others, elude legibility. It is as though the practices organizing a bustling city were characterized by their blindness. The networks of these moving, intersecting writings compose a manifold story that has neither author nor spectator, shaped out of fragments of trajectories and alterations of spaces: in relation to representations, it remains daily and indefinitely other.[23]

There is an erotics to de Certeau's writing about the walker's creative relationship to the city, an erotics that becomes

indiscernible from the cruiser's relationship to space. Both the cruiser and de Certeau's walker write their bodies and the bodies of their fellow cruisers and walkers into an ephemeral countergeography of the city as public space. For de Certeau, walking is a "space of enunciation" that appropriates the topography of the city in order to "act-out" a particular place by means of "contracts" of relations and movement agreed upon and enacted by individuals in more or less ephemeral and precarious ways.[24] Walking, like cruising, rewrites the city from below.

When thinking about countergeographical practices of this kind, parkour is another practice that resonates with the ways in which cruisers enact space. A practice of moving between two points in a city using the shortest distance possible and deploying athletic techniques to overcome urban and architectural obstacles, parkour was developed in the Parisian suburbs in the 1980s and 1990s by David Belle and Sebastian Foucan. With its history associated with youths to whom access to the French public space was—and continues to be—either denied or highly policed, parkour has been said to "loosen" the tight spaces of the city that, by means of the built environment, are designed to condition movement in certain ways.[25] By overcoming the city, the youths re-enunciate the city from below, turning obstacles into pathways despite the city's own attempts at regulating their movement, that is to say, their bodies.[26]

Like parkour, cruising also requires a subcultural body of knowledge and peer-to-peer transmission and pedagogy to successfully and safely re-enact or re-enunciate the city. While safety in parkour may mean safety from falling, from musculoskeletal injuries, or, at times, safety from the policing of public spaces, safety in cruising mostly occurs by means of a highly developed visual language of props and bodily

cues. That visual language allows the cruiser to be recognized by other cruisers while remaining unrecognizable as such by the straight population they may encounter along the way. From the backward glances in public parks to the hanky codes and other accessories popularized among gay men in the 1970s to signal their preferred sex roles and sex practices, a whole semiotics of cruising was created to ensure the desired legibility and safe illegibility.[27] Cruising codes—a fully embodied subcultural argot through which the body itself becomes language—allowed cruisers to forge counterpublic spaces of desire within the wider space of a city designed and built not with their interests in mind. That language, developed and disseminated by the subculture's own niche media, helped cruisers learn how to find one another and hook up as safely as possible, thus building ephemeral sexual autonomous zones in the straightest of our cities.[28] In that way, cruising is a social machine for the production of transitory sexual "heterotopias," to use the term Michel Foucault coined to describe "counter-sites, a kind of effectively enacted utopia in which the real sites, all the other real sites that can be found within the culture, are simultaneously represented, contested, and inverted."[29]

Yet, despite their fleeting, transitory nature as counter-spaces forged on sexual sociability, cruising as a practice of rewriting space was also partially responsible for the formation of a political homosexual consciousness. Not only did cruising allow homosexuals to develop a sense of belonging to a collective, but it also facilitated the exchange of ideas and opportunities for political organizing. Whether in New York, San Francisco, London, Berlin, or anywhere else where homosexuals started congregating throughout the twentieth century, meeting guys for sex is often also exposing oneself

16 Crossings

to new ideas. While cruising in itself is not sufficient to turn anyone into a political—let alone revolutionary—subject, as Aaron Lecklider and others have shown, many of the places where homosexuals sought sex were also places where political dissidents and organizers would often find themselves, facilitating the circulation of ideologies and the formation of allegiances.[30] In queer history, histories of sociability—including sexual sociability—are inseparable from histories of solidarity and political organizing. Cruising has historically been an example of that, of how sexual sociability can create a counterpublic sphere where ideas about the self, the other, and the collective can be forged and reproduced or otherwise troubled, inverted, done away with.[31] As Samuel Delany argues in *Times Square Red, Times Square Blue*, it was precisely the spaces of cruising he reminisces about in the book—namely the porn cinemas that once existed in New York's Times Square and that allowed casual sex among its patrons—that offered an important social and political experience to be found nowhere else: an enactment of democracy through sexual contact across races and classes: "For decades the governing cry of our cities has been 'Never speak to strangers.' I propose that in a democratic city it is imperative that we speak to strangers, live next to them, and learn how to relate to them on many levels, from the political to the sexual. City venues must be designed to allow these multiple interactions to occur easily, with a minimum of danger, comfortably, and conveniently. This is what politics—the way of living in the polis, in the city—is about."[32] Delany's view echoes the famous statement, put forward almost two decades earlier by Dennis Altman who, in *The Homosexualization of America*, spoke of the eroticism and casual sex that marked gay bathhouses—those most canonical of gay male

Introduction 17

cruising spaces—as "a sort of Whitmanesque democracy, a desire to know and trust other men in a type of brotherhood far removed from the male bonding of rank, hierarchy, and competition that characterizes much of the outside world."[33]

Yet, while Altman was alluding to the "dear love of comrades" evoked in the "Calamus" set of poems in Walt Whitman's *Leaves of Grass*, and while Delany praised the sexual enactments of democracy he saw taking place in pre-AIDS Times Square porn theaters before Mayor Rudi Giuliani "cleaned up" the city, cruising is not by default a democratic—let alone revolutionary—practice. Leo Bersani claimed as much in his famous 1987 essay "Is the Rectum a Grave?," written in the context of the early years of the AIDS crisis: "Anyone who has ever spent one night in a gay bathhouse knows that it is (or was) one of the most ruthlessly ranked, hierarchized, and competitive environments imaginable. Your looks, muscles, hair distribution, size of cock, and shape of ass determined exactly how happy you were going to be during those few hours, and rejection, generally accompanied by two or three words at most, could be swift and brutal, with none of the civilizing hypocrisies with which we get rid of undesirables in the outside world."[34] Ouch.

Yet, as one of us has noted elsewhere, cruising as a practice not only of rewriting space—including of rewriting our own bodies as space—but also of enacting a political revisioning of the social is always more of a potentiality than an actuality. It is always something one must strive for, rather than something one encounters fully realized in our worlds.[35] That is, if indeed one is invested in the political potential—rather than the actuality—of homosexuality. As the French revolutionary homosexual Guy Hocquenghem wrote in a 1971 pamphlet published by the FHAR, the Front homosexuel d'action révolutionnaire (Homosexual Front of

Revolutionary Action), political homosexuality requires a political homosexual consciousness:

> Let me explain: I believe that homosexuality lived in a conscious way is more than a form of oppressed sexuality; it is not only a way of envisioning emotional relationships; it consists of more than a position toward the family and heterosexuality.
>
> We are not revolutionaries who specialize in the sexual problem.
>
> I think that conscious homosexuals have a way of envisioning the whole world, politics included, that is unique to them. It is precisely because they live by embracing the most *particular* situation that what they think has *universal* value; that is why we don't need revolutionary *generalizations*, abstractions repeated half-heartedly.
>
> Firstly, we homosexuals refuse *all* the roles: because it is the very idea of Role that disgusts us. We don't want to be men or women—and our trans comrades can explain that best. We know that society is afraid of everything that comes from the deepest parts of ourselves, because it needs to *classify* in order to rule. Identify in order to oppress. This is what makes us know how to clock people, despite our alienations. Our inconsistency, our unsteadiness, frightens the bourgeois. . . .
>
> Living our homosexuality therefore doesn't end with sleeping with guys. It only begins there. Our view of the world is: "Love between us, war against the others," with it being understood that this "between us" is endlessly expandable, that the aim of this war is to spread it.[36]

It is such a standpoint of conscious homosexuality as an ever-expandable homosexuality that, according to Scott

Branson, makes Hocquenghem's thought so inherently and revolutionarily queer, well before "queer" started being used as a term to describe particular forms of activism and thinking. In the critical introduction to their translation of Hocquenghem's *L'après-mai des faunes*, Branson claims that it was the French activist and philosopher's conception of homosexuality not as a mere identity or even a sexual orientation but, rather, as a "liberatory force" that allowed Hocquenghem to claim that the utopian promise of homosexuality is the dissolution of identity itself, including the homosexual one.[37] And it was only through that realization—that political consciousness—that every homosexual would surrender their individuality and start existing as a collective: "All the conscious homosexuals are the FHAR: every discussion among two or three people is the FHAR. Jealousy, cruising, makeup, love—that's the FHAR."[38] Conscious cruising—that's the FHAR, and it is an investment in precisely that kind of cruising—that is, cruising as a sexual form of queer world-making—that brings the two of us together in this book. Cruising as a way of making a home for oneself and others, cruising as a form of hospitality, cruising—to paraphrase the late José Esteban-Muñoz—as a not-yet-here.[39]

On the Style and Structure of This Book

The chapters that follow present our own attempt at mapping a sexual-political ecology of cruising alongside four different but intersecting axes: space, time, matter, and breath. Throughout, we weave together our own voices and memories of cruising, and we think from them, trying to connect that which is singular—our memories—with a wider scale of the multiple or collective—the people who informed the

images our memories activate, the power-knowledge structures that both regulate and give meaning to our lives and bodies, the various assemblages we have found and continue to find ourselves involved in, however temporarily.

We deploy autotheory as a method that propels us beyond an analytic of cruising towards a speculative exercise on what cruising may one day become, what cruising may one day do. We take up Lauren Fournier's definition of autotheoretical texts as "works that exceed existing genre categories and disciplinary bounds, that flourish in the liminal spaces between categories, that reveal the entanglement of research and creation, and that fuse seemingly disparate modes to fresh effects."[40] In doing so, we embrace writing not merely as *graphos*—the description or expression of something that already is—but as a kind of *poësis*—the making or fabrication of something into being. In writing about cruising autotheoretically, we approach writing as a hypomnesic technique, a kind of memory-writing that "produces as much as it records the event."[41] We do so always in relation to a future, an orientation towards utopia that is always at the heart of cruising.[42]

In what follows, we bring those memories and ideas together in conversation with Liz's artistic practice, a third voice in the cruising that happens on the page. Our experiences of cruising are, in fact, the driving threads of this book even though they will emerge, run into one another and mix together in such way that the reader will find it difficult to identify with certainty whose voice it is they encounter. Just like bodies moving and finding each other in cruising, our individual voices, memories, and narratives blend with each other, mingle with each other, create something other and more capacious than the individual identities of our personal remembering. We cruise, become porous to each other, and come together on the pages of this book. We surrender our

Introduction 21

individuality to the erotics of cruising, to the plural and indiscernible.

In deciding to write from our memories, from our remembering, we attempt to write theory with our own flesh and with all the errors, gaps, glitches, and imperfections that both memory and flesh imply. This book is therefore an exercise less concerned with bringing the past seamlessly into the present and more with rewriting that past over and over again, reimagining it, re-remembering, re-creating it from the fleeting moment where we stand trembling.

We imagine cruising by means of memories, of images, of affects, pleasures, and desires. We get unashamedly horny, for knowledge needs eros, learning requires desire. While each chapter centers on one of each of four axes—space, time, matter, and breath—the linearity of writing necessarily betrays their multidimensionality as the axes always cross and intersect each other out there outside the page, beyond the book: where flesh meets flesh meets surface meets ground meets air meets grunt meets ecstasy and cry. There, where we get a glimpse of a something that promptly fades away.

1

Space

I wasn't sure how it would go. You can never know until you *know*.

I always imagined you to be the quiet type. Uncharacteristically patient. The kind of hungry bottom who doesn't ask for anything but, when formally invited, commits to the meal until the entire buffet is empty. You are the good boy who always cleans his plate, never leaving a crumb of evidence. You love to lick it clean, no need to even wash it. At least that's how I would do it if I were you. I would subtly have it all, until it all runs out . . . Until they all get tired, too tired to stay hard . . . Until the house lights go up, eyes aching, and you realize you are the only one still there, the only soft diffused curves left against the vernacular architecture of hard angles and empty holes. Squatting among invisible debris of liquids and solids. Remnants of hungry holes. Vestiges. Maybe some wreckage. An uneven foundation. Shaky relics of time. Obvious traces and varieties of residue. Or a warm body against the cold ground with wet muddy knees, as the first morning rays of sun beam down through the green tree canopy.

It's all very specific: ruins of sorts. Always ruins. You are not the last one standing (or kneeling) out of desperation or loneliness or pain. It is not because you feel unfulfilled and frustrated. It is just simply a matter of fact that I am starving for it. I am starving to know all of it, and I won't stop until the end is decided for me. I am not so interested in my own orgasm. Not so interested in serving my own dick here. I am simply becoming a receptacle. A hollowed-out fleshy vessel to be used. To be filled. To be used and to be filled in any environment, in any kind of space. A cinema. A hole. A theater. A maze. A stage. A booth. A podium. A gallery. A basement. A Speakers' Corner. Just use me. I am adaptable—the boys all know that—which is why they often save me for last. Make me wait until they are ready to dump the last load of the night. Ruin me.

Please ruin me. I imagine my knees might start to hurt a bit, but I don't care. It's part of it. The muscles that open my jaw—the lateral pterygoid, digastric, geniohyoid, mylohyoid, omohyoid, sternohyoid, sternothyroid, stylohyoid, thyrohyoid—I can feel they are tired. Yet, they refuse to give up. Like when I am on all fours, on stage with my tongue hanging out, spit pooling down my tits, hitting the dancefloor, infinite flesh holes opening for the audience, they refuse to get tired. Sometimes I stop and take a sip of water, or elegantly look to the side to stretch them, to give them a rest, but I do it in such a way that no one will notice, because I refuse to be *that kind* of bottom. My mouth is not just strained, it is getting worn down.

Maybe I will be left and found as a fossil lying in the darkroom, or buried under rotting leaves, or found under the recycling behind the supermarket. Whatever happens, I am committed. I will perform through the pain, through the fatigue, the way I imagine a ballet dancer does, while

maintaining what seems to be a visible effortlessness. Many times, I've been told "you make it look effortless." And then I become the most fulfilled unfillable hole. Again and again. And again and again.

It turns me on to think about you/I/me/us left behind as fossils in cruising zones, because cruising zones themselves are fossilized time machines. Instead of dust, dirt, or ash, our soft tissue is buried in cum, piss, blood, sweat, poppers . . . That's how we sediment, how we get hard. We, our remains, blanketed by urgent sediment, shielded from scavengers, erosion, and decay. Decomposing down to our core, left to support the others who will come. Structures imprinted on interior surfaces. Indentations of a fist left in holes. Space left inside space. Architecture.

There is this book that has become a kind of old sacred book, a prophecy yet to be fulfilled, a compass for what could have been, for what—I hope—will one day have been. It tells a tale of the faggots as they were created and joined the women, and the queens, and the fairies and all their other friends fighting, resisting, and living in the empire of men. Faggots aren't men even though they can pass in a world of men. "The faggots and their friends live the best while empires are falling," the book tells us. "When an empire is falling, the men become so busy opposing the rebellions elsewhere and searching for the reasons why this is happening, that they have no time to watch the faggots and their friends at home," it tells us.[1] I think that is why so many of us have found ourselves together in the same space. To be precise, we live better in the ruins of empires. The ruins give us solace and the ruins protect us. And from the cracks in the ruins that witness but speak not—from there where cum and stone, leather and wood, spit and steel touch one another—new beautiful forms of life sprout in all their fragile glory, in all

their poetic determination. Dark roses of the present, scents of precious flesh, of tobacco, of sweat, piss, and soil. We fuck one another and, in doing so, we honor each other.

"The memory appears at night when the bones are quietest."[2]

It was dark that night, but not as pitch black as I would have hoped for. My eyes adjusted too fast, and it was as though I could see in the dark. I was hoping to not even be able to watch, but rather just rely on feeling the abyss, falling into the dark hole. It's exciting when you can feel the corners but not see them. Fingers searching. Sometimes rimming a hole in the wall that could also be a hole in a body. Light coming through the ripped seams will just continue to expand, because what is the point of repair in a space that is in constant use? Architecture. Hard and soft. Flesh and nonflesh. Objects of desire. You and me. And also them.

"Two rules govern these places of nourishment. First, all must remain quiet so the soft sexual noises can be heard. Second, anyone who is done must do. If you get, you have got to give."[3]

You and I had never gone cruising together before.

While we sat in the darkroom of that most infamous of Berlin's cruising bars, I was thinking about how I hadn't been in an explicitly marked cruising space since early 2020. "Explicitly marked" meaning the darkroom of a cruise bar, a known area in a public park or bathroom, or even a sex party with a playroom, maybe a dungeon. That also means I hadn't been in a cruising space since I started taking testosterone full-time nearly three years ago.

I just watched. I can't believe I *just* watched.

Voyeurism, too, is participation.

I watched and turned men away, which was a new experience for me. I liked it. The handful of times I had

26 Crossings

successfully passed in cruising spaces were far and few between. My most successful experiences had been in bear bars as a fat body, going to cruising spaces with unquestionably readable male people, or on a few special gem-like occasions where I was just a hole. Mostly, my cruising career had existed off trying to stay quiet and stealth until I'd be "found out" and promptly kicked out. The most extreme experience of that occurred in my early twenties, when a patron started banging on the door of the glory hole video cabin I was occupying in the back of a gay porno shop in Chicago.

"It's a girl! It's a girl!"

Nothing remarkable. Nothing we haven't heard before.

I remember the first time I watched that video. You had sent me a few of your works as I wanted to bring you into my classroom. I remember how my undergraduate students immediately became fascinated by you, even before they got

Liz/James/Stillholes, digital video, 2003/2017, Liz Rosenfeld, Chicago. Courtesy of the artist.

Space 27

to meet you and ask you questions during the seminar, on video call. I remember them all lining up to sit in front of the camera and talk to you. I remember how much my "cred" among them grew—I was the lecturer that had brought *you* in.

I mostly remember the shaky Handycam and the audio of the planning conversations between you and James, about how you could succeed in sneaking into the shop and, from there, the video cabins at the back. It gave comedy, it gave *Mission Impossible*, but it also made visible the ways in which we protect ourselves from things we tell ourselves we do not want. There is so much to be said about "safe spaces" populated by equals, especially when such spaces have been so difficult to get and are always at risk of being taken away. But then what exactly do we consider to be a space of equals—a space of peers—when the smallest differences among the otherwise most alike can erect such insurmountable barriers to their contact, blinds preventing them from seeing one another? Or when the most obvious differences are ignored, because bodies are just supposed to be bodies in cruising. Holes are supposed to be just holes. Is a hole ever just a hole? We—you and I—we speak from queerness, transness, working class and upper-middle class. We speak from experiences of specific education, the way into some kind of legitimized intellect in our chosen fields. We both speak from class switching, from chronic illness. And we both speak from Whiteness. One, a U.S. fat genderqueer who has recently just crossed the threshold of testo use enough to pass quietly as another fat White man in places like public transportation and the street. The other, edging the peripheral ambiguity of Southern Europe, with all the different readings and often misunderstandings the peripheral affords as it encounters the center. That is to say, we speak from

different embodiments of Whiteness in a cruising context. Anxiety is real in safe spaces too, cruising areas being no exception.

"Where are you from, mate?" Grindr guy asked me as soon as he turned up at my apartment. "What do you mean?", I replied. "Well, you must be South American, Greek, or maybe Turkish . . .'cause you aren't White, mate."

I decided to end the conversation there and then and just get on with the fucking.

One of the Tom of Finland comics starring Kake, his famous nondescript faggot lead character, has been stuck in my mind for a few years. The graphic story is titled *Pleasure Park*, and it depicts Kake cruising in a park that turns into the grounds for a mass orgy. New men start popping up as other men leave—a multiheaded collective fucking machine, a horny Medusa that turns men into faggots. In your book on gay pig sex cultures, you refer to this story. You were less interested in how every male figure in the comic strip has the same face—Kake's face—and is therefore a clone of a clone of a clone, than in reading it against the grain. Could the cloneness of the clones depicted by Tom be less about their identity, their self-sameness, and more of a metaphor for how things *could* be, of how sex could one day be? Namely, that every body we fuck can always be replaced by any other body; that it does not matter who you fuck but rather that it is fucking itself that matters. You wrote that "sex cannot be fully reduced to a specular narcissistic system whereby the one always relates to himself at the level of the imaginary," by which you meant fucking someone who looks like you, fucking your mirror image. You continued: "Instead, what we have is a more complicated scene, an assemblage where the subject relates to *different timbres or hues* of an immanent sameness—sailor Kake to army Kake

to cowboy Kake to labourer Kake to policeman Kake—in such a way that each man cannot be reduced to a self-enclosed interiority that precedes its encounter with others nor by an *a priori* lack but, rather, by his capacity to extend into the other as he himself emerges as singular-plural, evoking new *communal* worlds as he does so."[4]

I get it. I do. Tom of Finland depicted the sexual glory, joy, and freedom that defined gay clone culture. Through hunky, erotic drawings of cruising, BDSM, and hot sexual acts, he created a liberatory space for gay masculinity that has become a beacon and cornerstone in homosexual history. But what has always surprised me, despite the inclusion of Black and Brown bodies in Tom's erotic fantasies, glaring Whiteness still prevails in his art. It is obvious a White gay man drew those bodies, and that the cruising spaces he helped us imagine do not necessarily live up to their promise of being spaces of *only bodies and holes* undisturbed by all the other qualities through which bodies and holes come to be ranked.

You disappeared and reappeared. You always knew where to find me. "Get out there," you kept saying when we would find each other again. But I felt an uncommon feeling of deep quiet. One I had never experienced in a cruising space before. Quiet as a kind of protective tool, yes. I knew that feeling . . . as in, pre-hormones, I would try not to speak as much as possible. I would *quiet* my body language . . . soften my eyes . . . use strategies I had learnt through making performances my entire life—attempting and often failing at them: *Don't let your hand linger over another body for too long. Seamless transitions. Keep clean angles. Clear contact. Unfocused eyes. A relaxed but alert body. Stay open. Don't shut out the other performers. Let the audience in. Hold the space and create clear boundaries.*

30 Crossings

And when I say "failing," I mean both in cruising and in performing. I forget my lines, I expose my body too soon, I am the worst at timing. And I really can't act or pretend at all . . . My domestic partner always says that I am at my best when I am just being myself in my work.

"Not tonight. Thanks," I said to another fleeting groper. Pre-T, I used to get so horny when men acknowledged my faggotry. I would go home and jerk off all night. I felt so seen, which was rare. Now, I have a pubescent handlebar stache coming in and sideburns for days. A happy trail that expands over my large stomach, resembling a bed of moss. Thick hairy thighs and a small patch between my tits. If I don't shave for three days, I have a five-o'clock shadow. And if I don't shave for two weeks, a beard begins to arrive, travels up and connects to my burns. One could say I am on my way to becoming a Tom of Finland daddy . . . oh no! So many trans masculine people I know and have dated have found that being acknowledged in spaces exclusively marked male—specifically gay male spaces like cruising spots—to be deeply formative and important to their own identifications. But I have noticed some things I didn't expect about myself since I started transitioning, and one major realization came to me that night, sitting in the darkroom with you, watching you give a blowjob while I turned away men. I realized I am not searching for that feeling anymore. I don't feel like I need to be acknowledged or seen by gay men. In a way, I get off more on feeling invisible. Watching while feeling the staleness of the air, thickened as it gets pushed around by roaming bodies. Inhaling the damp combination of mildew, stale fluids, and poppers. Cool stickiness. Sometimes a brush against my thigh. It feels like . . . enough. I don't understand why entirely, though. At last, I have access to darkroom dick without being kicked out, and I just want

to be left alone to sink into space and feel my own clit rubbing between the folds of my pussy, as it grows into a small cock. To sink into my new body, the one that is still my old body. To sink into this old space that feels like a new space.

In her book *Cruising the Dead River*, Fiona Anderson refers to ruins—specifically the West Side Piers of 1970s New York City—as spaces that delinearize cruising experiences, that deny histories—of sexuality, of the body, of the city itself—any kind of reassuring, totalizing unfolding. Ruins propose both nostalgic longing and future promises, not just expectations of impending collapse and destruction:

> The ruin, then, . . . was both the place where the past is reactivated and the material that reactivated it. The queer archival tendencies perceptible in writing on cruising the waterfront in late 1970s New York speak as much to the physical and imaginative potential of the ruin as to the nonlinear, ephemeral practice of urban cruising. . . . Cruising finds its spatial parallel not in the metaphor of the busy street, the modern bathhouse, or the public park, but in the waterfront ruin, dilapidated and decaying, economically functionless and willfully nonproductive.[5]

Like ruins, I would imagine most cruising spots are not maintained with any intention. Who cares for that which has no hope? Perhaps only the hopeless. Perhaps they clear up some glasses before the doors are locked for the day. Perhaps, in a best-case scenario, they pick up the dirty tissues, the empty bottles of poppers, the empty drug baggies at the end of the night. Still, they know it'll all come back again, that you can't rebuild what only exists through being lost. We're

32 Crossings

not talking Notre Dame Cathedral here, we're talking the "Temple of the Butthole."[6]

I think about ruins every time I am in a cruising space: The worn-out adhesive of duct tape falling off the edge of glory holes. Temporary wooden structures and walls fraying at the edges. Moss. Mildew. Compacted soil. Warm air, ripe with sweat. Lost socks. Overgrown trees. The smell of spilled beer on concrete floors. The lingering rush of poppers you can just about feel. Clear-cut shrubbery. Graffitied walls. Dying leaves as the seasons change.

Ruins are always in progress, never at a beginning or an end. In medias res. That is even the case for ruins that have been replaced, gentrified, erased. Those structures stand on knowledgeable ground: Concrete. Water. Sand. Brick. Cobblestones. Land that still lives what has happened there.

My parents live right across the street from the brand-new shiny sports centers that replaced the old West Side Piers. I used to go down to the piers when I was in high school in the 1990s. Not to go cruising, specifically, but to hang out, to meet other queer youth, and to smoke weed. I've spent a lot of time in the last several years walking along the piers with my dad, while he was battling cancer. We started real slow, uncertain if he would be able to take the next step. We would take about ten minutes to walk across the road and sit at the Christopher Street Pier for half an hour. As he began to heal, we would walk a little farther every time, and he would point out what was new about "the West Side Highway/River Park area," as he refers to it. "Look over there, isn't that neat?! They built a park along that pier called Little Island, an artificial island described as 'rising from the remnants of Pier 55.'" Constructed with 132 tulip-shaped pistil-like concrete structures, this park is designed to

withstand a once-in-one-hundred-years flood. It was built on ruins.

Will they remember that what still rises from the remnants of Pier 55, echoing across the Hudson River, are the ecstatic cries of our own?

I remember being in high school—it would have been the mid-to-late 1990s. I must have been fourteen or fifteen. We had to do an individual project for Portuguese class. I had just recently found out about the works of this gay Portuguese poet writing under the pseudonym Al Berto at the local public library, where I would often spend the afternoon after school. This was around the time of his death, but I didn't know that, not yet. I remember deciding to do my project about his work. I mostly gravitated towards a poem he had written about cruising, about the ruins left by cruising. It is called "Truque do Meu Amigo da Rua"—that is, "Trick of My Street Friend"—and it did something to me. It's not like it made me "discover" something about myself. No, it *did* something to me, something I needed done. In the public library of a small rural Portuguese town—in a building that used to be a Dominican convent, then a military building, then a hospital, then the library, then later amplified to include an art and archaeology museum—there, in the public library of that small rural Portuguese town, a library named after a local poet and dramaturg known for having written some of the earliest modern Portuguese poems and plays with homosexual themes and having paid the price for it, it was there, in that public library that I first found Al Berto's work. It was there that, through his work, I felt—for the first time—things I didn't know I was capable of feeling, things I couldn't name, things for which I had no descriptive framework, but things I felt nonetheless, unconstrained by language, by naming, by sense, yet things

34 Crossings

that mattered deeply at the level of my flesh. Things that made my body tremble with desire. Writing about it today, at the time of new old moral panics about books in libraries, about the things taught in schools, about the things teenagers should and should not be able to see, it doesn't cease to amaze me that, in a very small rural town of an unremarkable small little country on the periphery of Europe, there was a library that taught a teenage boy about the expanse that is desire, and that there was a teacher—an older woman with an always-perfect hairdo held together by cans and cans of hairspray—who not only allowed but encouraged that boy to write about the things he felt and thought as he read those poems. Her name was Aurora, "Dawn."

While I watched you engaged in full blowjob action, I must admit I felt a little guilty, because I was distracted. I wanted to give you my full attention, whether you knew I was watching or not. I didn't need you to know I was watching. But I thought at least you might feel someone's eyes on you, another gaze sweeping the space. I have no idea if you are into being watched, but I know I am, and I like to give what I like to receive. I believe in Karma that way. But that evening, while I witnessed you diligently deliver, I was simultaneously irritated by the gaggle of young folks just simply hanging around the darkroom as if it was their own private bar to party in.

"Like, OMG, look are those HOLES FOR DICKS? OMG! OMG! OMG! EWWW!"

Now, I don't have a problem with prescribed space shifting and morphing to hold many kinds of experiences for different people. However, that evening, my brain was hooked on what it could only call these young folks, "the gentrifiers."

There was a time when they wouldn't come here. It was too dirty, too trashy, too sick and infectious. One of my

intellectual lovers who died too early to be able to fuck me but who still fucks me with his words once wrote:

J'ai arrêté de pomper mais je suis resté en deux, fasciné par ce que je voyais, la bite que je suçais, ces mains, ces entre-jambes, tous ces corps de plus en plus indistincts qui m'entouraient. Je pouvais m'engloutir dans ce magma de mains, de bites, de bouches. Je pouvais me mettre à ne plus rien en avoir à foutre de savoir à qui appartenait quoi, qui était gros, vieux, moche, contagieux. Je pouvais très bien partir, devenir fou, bouffer chaque bite qui passait, devenir une bête, ressortir des heures après, les vêtements déchi-rés, tachés, nu, couvert de sueur, de salive, de sperme. J'imaginais déjà comment les bourgeois du Trap me regard-eraient comme une salope, une trainée. Je me suis redressé d'un bond, les larmes aux yeux. J'ai trébuché jusqu'à la sortie en retenant mon jean avec mes mains. Je me suis rhabillé sur le seuil, le cœur battant, sans oser regarder devant moi.[7]

[I stopped sucking but stayed bent in two, fascinated by what I saw, the cock that I sucked, the hands, the crotches, all those increasingly indistinct bodies that surrounded me. I could drown in this magma of hands, cocks, mouths. I couldn't care less about who owned what, who was fat, ugly, contagious. I pretty much would get off, go crazy, eat each cock that passed by, become a beast, leave hours later, clothes torn, stained, naked, covered in sweat, saliva, sperm. I imagined how the bourgeois at the Trap [Parisian gay bar] would see me as a slut, a tramp. I got up abruptly with tears in my eyes. I stumbled to the exit holding my jeans in my hands. I got dressed on the doorstep, my heart beating, without daring to face ahead.]

I like to think the tears on the face of Dustan's narrator were not tears of shame. At least not tears of shame that prevented him from seeking what he would have been. That is, from inventing himself. Shame is, after all, central to our processes of developmental individuation. That is, central to the processes through which we become that which we will have been. "The forms taken by shame are not distinct 'toxic' parts of a group or individual identity that can be excised. . . . They are available for the work of metamorphosis, reframing, refiguration, *trans*figuration, of affective and symbolic loading and deformation," Eve Kosofsky Sedgwick reminds us.[8] It was thanks to his own shame that Dustan became the man I would have loved to have been fucked by in that Parisian darkroom.

"Um . . . can we just sit in this corner and smoke our joints . . . I don't want to see penises. I don't want to see sex."

"Then why the fuck are you down here?" I mumble to myself under my breath. It's almost a kind of bad humiliation porn where the zoomers and millennials hang out in the cruising area, ignoring what is happening in the space itself, and talk about fashion while they snort cocaine, smoke cigarettes, and "look fabulous." This, by definition, ruins what apparently *is* and was a "safe space" for queer men to go cruising. Yes, queer men and—I know—always men who are assumed to be cisgender. But it is not the cisgenderness of bodies that creates an unsafe space for people, it is the assumption of what gender is in the first place . . . and of what it does. The queerest of all bodies can still be patriarchal, racist, bigoted, small, impenetrable, impermeable. In the end, it's about respect. But we aren't socialized in a society of expansive respect for bodies. We are trained in a society of patriarchal currency, where socialized AMAB subjects don't have to think outside their own experience,

and AFAB subjects are socialized to hate each other.[9] This is one prominent reason why cruising space has historically been so male-centric, and it continues to mostly function that way. When gendered upbringing tells you that "boys will be boys," that men are always horny but women should fear their own desires to the point of repressing them, and when inhabiting public space has historically been seen as the privilege of men, it is no wonder cruising spaces became marked as the playgrounds of faggots.

Different iterations of this phenomenon seem to be happening a lot lately. The lack of discussion, information, and education, and the challenges presented by dangerous expectations regarding safe space and consent politics, have made queer space more dangerous by a combination of both straight and queer people alike. Gender, race, body politics— they will always play lead roles in how the spectrum of queers frames and discerns which bodies are welcomed in cruising spaces. It's a tired reality that can never be undone even by the most politically correct, who are also often the Whitest people in the room. Perhaps what we need is to recognize our own imperfectability, how we will always fall short of the stories we tell ourselves, how being queer does not give us a "get out of jail free" card when it comes to the very structures against which we set ourselves because we, too, are implicated in them. "Where there is power, there is resistance, and yet, or rather consequently, this resistance is never in a position of exteriority in relation to power," Michel Foucault writes.[10] And I think it is also a huge reason why I haven't been so excited to go cruising in recent years. Predetermined and highly policed cruising experiences— unless open to embracing an unknown temporality and expectation of bodies—have ruined the essence of what cruising could be. Even attempts to counter systems of

exclusion in cruising spaces tend to result in self-righteous queer posturings that produce their own impermeable systems of exclusion predicated on subcultural apparatuses of power-knowledge. That shouldn't come as a surprise, though. Already in the 1970s, a British scholar of subcultures wrote that members of a subculture "in part contest and in part agree with the dominant definitions of who and what they are, and there is a substantial amount of shared ideological ground . . . between them and the dominant culture"[11] Or, as Brazilian philosopher and father of radical pedagogy Paulo Freire put it, sometimes "the oppressed find in the oppressor their model of 'manhood.'"[12]

I know everyone wants a bite. I am the first to admit and share that I need and have needed cruising space to feel myself, and even in some moments, to feel at my queerest. The room to cruise has quite literally shaped my artistic work, identity and sexual relationship to myself. I learned to read bodies without words, sensitize myself to desire, rejection . . . to history. To understand why cruising must thrive while queer bars continue to get shut down. It has helped me understand how public space is policed not only by the state and its hegemonic ideologies, but also often by those who inhabit them counterhegemonically, cruisers themselves. And, sure, I think everyone should be able to touch the space of cruising, but only if you are serious about it. And when I mean serious, I mean respectful. In true historical form, as the politics of queer bodies have always been under attack, weaponized, and trapped in the propaganda of visibility, it is not just the space of a dominant ideology gentrifying these bodies; it is the queer bodies themselves that are gentrifying each other. Classic panoptic shit. We can hear Foucault forever sighing in the afterlife. If you don't want to see a cis dick, then don't go to gay male cruising areas, and don't try to

infiltrate or take them over, either. Instead, like Kathy Acker, *live* them: cruise, pick up, plagiarize, inherit, steal, redefine, dismantle, and, while doing that, remember to celebrate them and the histories in the ruins. Acker writes: "I have become interested in languages which I cannot *make up*, which I cannot *create* or even *create in*: I have become interested in languages which I can only come up upon (as I disappear), a pirate upon buried treasure. The dreamer, the dreaming, the dream. I call these languages, *languages of the body*."[13]

Cruising, too, is (re)writing space with a language of the body but not of one's own, if by that one means a language one owns. The language of cruising is such that one always comes upon it like "a pirate upon buried treasure." It is a language of the body as a stranger even to ourselves. A language of the body defiant, the disciplining of which is a condition of our own imaginary cohesion, of the very phantasmatic identities to which we nonetheless cling, often to survive. Yet, the languages of the body, they do nothing but open cracks in the self, pulling the modern autonomous self—always more ideal than actual—into the terrifying sexy abyss of self-unknowing.

You mention Kathy Acker. One of her bastard children with Jean Genet kept me horny as fuck throughout my early mid-twenties. I first read it for a master's seminar during my first year in London, which was also a year mostly spent dancing and cruising from club to club, from sex party to sex party, from sex party to university classroom. The text is a short story included in a collection edited by Alison Fell entitled *The Seven Deadly Sins*, where each writer writes on one of the capital vices. Kathy was obviously tasked with Lust—what else?—and I never felt so horny for the faggot in her voice.

"Tongues were as hard as metal. The pricks are harder than tongues."[14] And then:

> My other hand took hold of one of his thick hands and forced it to touch my penis. Dolphins leapt about the prow and flying fish scattered before us almost in golden showers. Mick stroked the naked penis under the wool trousers, then on his own accord unbuttoned my flap. Dead leaves falling, jagged slashes of blue sky where the boards curled as if from fire apart. Mick squeezed my penis so hard that I whispered for a suck. Mick bent down only the upper part of his body and parted his lips. Violet twilight yellow-gray around the edges, color of human brains.[15]

Ruins.

We can also turn to the great Samuel Delany, one of the first African American queer writers to write explicitly about how the gentrification of Times Square destroyed a precarious ecology of interclass and interrace crossings in porn theatres where men went to seek out sex. In *Times Square Red, Times Square Blue*, he writes:

> Younger gay activists find it hard to articulate the greater discursive structure they are fighting to dismantle, as do those conservatives today who uphold one part of it or the other without being aware of its overall form. But discourses in such condition tend to remain at their most stable.
>
> In order to dismantle such a discourse we must begin with the realization that desire is never "outside *all* social constraint." Desire may be outside one set of constraints or another; but social constraints are what engender desire; and, one way or another, even at its most apparently catastrophic, they contour desire's expression.[16]

I am sorry, but—yes—all this flooded my thoughts as I watched you that night, our night. I was frustrated. Also excited. I was excited by the space created between me and the bodies that propositioned me. I thought about all the spaces my actual body could provide. The folds and holes. I remembered one of my more successful cruising encounters, sitting in an old porn theater in Chicago, the Bijou. I secured the tip of my thumb to my fingers in the form of a hole and jerked off the guy sitting to my right while we watched an old film of a heterosexual couple fucking in Technicolor. They both seemed mechanical, almost like robots who had been preprogrammed to act out what they thought sex should be like. To my left, a few seats down, there was one man on his knees, supported by the row of movie theater chairs behind him while his head worked between the legs of another guy. I liked how my hand became another kind of hole, and how it was restricted by space—how the row of chairs forced us to think about how bodies can fit, how bodies must figure out how to acknowledge and pleasure each other.

As my body continues to morph and change from age, from chronic illness, from medication, from substances, from old injuries and new pains, from new possibilities, it is scary—like for everyone—but I like it. I am even excited by it. Like a cruising area, my body, it is a ruin in slow motion somewhere. Except that, unlike the reality of cruising, this body doesn't have a possibility for re-regeneration, whether natural or forced. Much like the gentrification of cruising spaces with new buildings, facades, clear-cut forests, and young people getting the wrong kind of thrill, fleshy bodies can always try to put up a new facade, to implant—to build—something new . . . to transition. However, the old structure

42 Crossings

is always there, underneath the quick fix or the more gradual tune-ups, whether affective or material. The old bones of my body are its ground. The new Progress Flag litters the West Side Piers, memorials to the ruins that used to be. Like the young fashion queers hanging out in that Berlin darkroom, reminders of all that is absently present.

How can one build a memorial to ruins if indeed the character of the ruin—namely, its becoming dust—is antithetical to that of the memorial understood as something that lingers, that stays, its desired unchanging permanence as if memory was made of stone, of bronze, of stuff we build in failed attempts to fight the impermanence of our own memory and of the archive that is our flesh.

Reflecting on her first encounter in a New York gallery with a drawing that Cuban artist Ana Mendieta had made on a tree leaf, Jane Blocker writes of being overcome by an immense fear that she could easily "crush the leaf to dust" even though the leaf had been preserved in a box, trying to contain as much as possible its decay:

> What could account for this hysterical fear? What kept me from crushing the leaf? The box did; it marked the leaf as precious, as an object to be saved. In the box I began to see the act of historical preservation through writing. Writing history about work like Mendieta's was like keeping a dead leaf in a box under your bed; it was like saving something that had already been lost. Had I pulverized the leaf, in other words, it would have been more threatening to history, more destructive to me, than it would have been to the leaf itself. What would a history look like, I wondered, that took the death in Mendieta's work seriously? What kind of history is it that does not save?[17]

What are the ethics of saving that which only exists through its decay and therefore of stopping it from being what it is? What are the ethics of saving a ruin and preventing it from ruining? In that sense, are monuments to queerness and queer sex impossible? Apart from—perhaps—through the continued re-enactment of those histories in our own ephemeral bodies, decaying archives of decaying histories, ruins evoking other ruins that will, in turn, be evoked by ruins to come in a never-ending return of vulnerable flesh that does not write but still records?

At a certain point, I headed upstairs from the darkroom because I had to pee, only to find that the "men's" toilet didn't require a key, while the "women's" did. Which meant that if one needed the toilet and couldn't use a urinal—and, in my case, the "men's" toilet was packed—one was forced to out themself by requesting the key to the "women's" bathroom at the bar. "An unfortunate flaw in this architecture," I thought, "but at least they have a 'women's' bathroom. . . . But . . . why aren't they just gender-neutral?" Would that have solved anything? I don't know. Post-pee I tucked into an empty booth, texted you that I had gone to get a drink and told you to "take your time, you hungry bottom."

I like that we were on the same page.

Begrudgingly, as I get older, I admit that I am a deep romantic, and I consider one of my first romantic relationships to have been with cruising. I fell deep in love with it, and I continue to be. As I typed what became these thoughts into my phone under the cringey note title "Field Research," I went back to thinking about how you and I met our "in-love" lovers, the people we both call our boyfriends, our girlfriends, our partners. Ironically, we both cruised them while at work in museums. I remember you told me once that you smelled him in the museum archive first. I quite literally

handcuffed her to a museum in a performance art piece by an artist I was assisting. And I held the key while I circled around the museum for three hours, checking in periodically to make sure she was okay. I think about these stories of how cruising spaces have been architectures for so many kinds of encounters. Not just the fleeting or temporary, but also the ruptures that have led us to put down roots in our own ways, to expand desire, to expand our bodies, expand the self.

Was I cruising when I met him? Or was I at work? Does that even matter? Would it be bad to get horny while working? When you work in our fields, horniness is often a side effect of work itself. Perhaps even a driving force. I mean, we met in a work context but indeed smelling him as he arrived reconfigured the space in my mind. It was tough to stay focused, I'm telling you. I managed to keep my cool—I think?—to be professional and the like, to be a good boy. (I love being a good boy.) But then I drank one too many beers with dinner the following evening and ended up ruining the work/play divide with a direct message: "Wanna come to my hotel?" or something like that. He did. The following month I returned to Berlin for more research and went straight from the airport to his apartment. Where does the archive begin and end, when the histories we search for take us to the most unexpected of places? Sometimes sitting in the kitchen of a small flat share in Wedding drinking cheap wine from the discount supermarket because everything else was closed is as great a place to start as anywhere else.

RUINS: Part I (2023) is a performance in which my collaborator an*dre neely and I built a cruising atmosphere from the used and unused material—the debris—of the theater space. Chairs were sculpturally placed around the space, emulating ruins, directing people to get lost only to encounter projections of manipulated Super 8 film that we had

RUINS: Part I, live performance with mixed media, 2023, Liz Rosenfeld and an*dre neely, Berlin. Photo documentation by Mayra Wallraff. Courtesy of the artists.

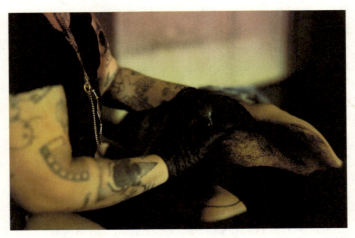

RUINS: Part I, live performance with mixed media, 2023, Liz Rosenfeld and an*dre neely, Berlin. Photo documentation by Mayra Wallraff. Courtesy of the artists.

recently shot at the cruising spaces of our youth between Lisbon and New York City. We turned to the photographs of Peter Hujar to inspire choreographic scores in which we came together in various tableaux over the course of three hours.

A secret handshake. An insertion and withdrawal of needles into each other's bodies, licking the dripping blood left from our tiny wounds. Singing. Losing each other and finding each other in the ruins of the theater. In the ruins of our own cruising histories, the ruins of our bodies, that are our bodies. Blood. Sweat. Fluids. The soundtrack by sound artist Nicol Parkinson, an experimental reimagining of the 1969 self-titled *The Velvet Underground* focusing on Lou Reed's relationship with trans actress Candy Darling. Two trans-identified kin intergenerationally showing each other ways. Like the theater, like the cruising spaces of our youth, again we acknowledged one another as ruins in progress.

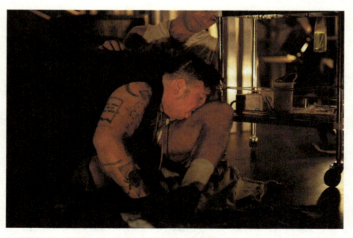

RUINS: Part I, live performance with mixed media, 2023, Liz Rosenfeld and an*dre neely, Berlin. Photo documentation by Mayra Wallraff. Courtesy of the artists.

Space 47

Flesh expands the capacity while masonry holds the frame. Carnality requires taut, engaged energy against the direction of thickets and coppices. I know where the fuck tree is because the other trees show me the way. I can find you in the theater because I can feel you in the space. The sharp angles and round edges map out the parameters. The heavy air. The thick breathing. They stretch and amplify; they stagnate and hold still.

The shifting eclipses of searchers in the darkroom lead me to you.

My lover and I keep talking about "meeting in the darkroom." But without saying it to each other, we both know that this will never work. We both know that arranging sex will just kill the vibe. We have fucked in public quite a few times. Sneaky gropes on the street in the middle of the day. Nipples pinched while clits get hard. Wet pants. Sticky pubes. Pretending to be asleep while her hole drips down my hand under towels at the "straight" sauna. We fucked in a hot tub while a heterosexual couple watched, ignoring that there was anyone there. I am not sure why, but we seem to enjoy public sex in explicitly non-public-sex-assigned spaces, the other proposition being too obvious, too defined.

All the spaces I fucked in: I started listing them and they all became the same. Space is space. And fucking is fucking and fucking makes space. All the spaces I can imagine fucking in: Pretty much the same thing happens. They melt into structures. Into just a bunch of locations. Into expanses. Into nothing specific. That is how I want to fuck. That is how I want to get ruined and be ruined.

Sometimes all you need to fuck is the night.

2

Time

I can't stop thinking about fissures. Tears. Cracks. A separation of parts. An organic division. Scallops in an opening. Grooves. Creases. Crimps. Cuttings. A puckering. Depressions. Impressions. A corrugation in flesh and time. Deep splits and valleys. In the more linear folds of my thoughts, fissures in time rupture at one point and stretch to another. They are tiny and impactful. Like small waves moving grains of sand. Leaving unnoticeable traces that stretch and erode like canyons. However, I have a hard time thinking about us, you and me, Liz and João, as binary points. When I conjure you in me, you move and see me in all the directions. Directions unnamed and unknown. How they move and we move them. And when I try to place these directions in relation to us, a timeline of our relationality, our intimacy and friendship—how we met, how we move, how we know each other, in all the ways that we fuck without fucking, how we feel seen by one another—I wonder what the point is, really. For even the queering of time feels too defined. Too easy. Too lazy to turn to. Rather, we are magnets that attract the cruising of time. This is how we met and continue to meet: we collide in cruising time.

Someone recently told me about symbionts, a life-form on *Star Trek* that lives inside other bodies while they absorb and hold their memories and emotions. When these bodies die, the Symbiont migrates to another body, where it takes the knowledge of the previous host while simultaneously storing the memories of the new one. I think I can count the number of moments our bodies have touched. And yet, I can't recall the first time we met. All the fissures between the times we have gotten to be and will get to be physically together again. Brain merging with brain. Gaze upon gaze. Flesh to flesh.

We probably started with a few nervous handshakes. Then quick awkward hugs. Now a distant, yet deeply familiar sensation of queer kin touching queer kin. I remember— from a few summers ago—the weight of your head on my shoulder, posing for a photo. I felt so large next to you. I liked it. The first time you saw me perform—I think it was the first time—I was dancing in a piece I couldn't connect with. I remember feeling so disappointed that your first experience of me performing live was in the work of another, a work in which I had to disconnect from my body to perform. Performers say the goal is to live the work on stage. Only fake it if you must. But I think that is bullshit. How many times have we had to fake it to make it? How many times have we had to dissociate in order to pass? To exist in different time? To cruise? To fuck? To feel seen? To code switch? Back then, I didn't know you the way I know you now. I didn't know how to read your cues. The way you get anxious and excited at the same time. The way you deal with desire and longing in a moment. How you effortlessly work out the journey of ideas like I would imagine you know how to jerk yourself off. But you hung around until the audience was almost gone. You hung around. We said hi.

Once, when we were drinking beers outside, you put my leather jacket on when you got cold. I remember thinking how it suited you. My leather fit you in a completely different way than it fits me. Fit with you. Wrapped around your torso in a kind of time and space it could never wrap around mine. Usually, it cooperates with the way my body expands, as if the leather is making an exception for me, because this jacket is my cruising jacket. This jacket knows that. On you, it hangs perfectly. Like it is brand new. Hot off the rack. Meant to be found. I think about the tiny fissures in that leather. Your fissures. The ones you left behind.

I know now it was no longer summer, a reminder that time was moving through us that one evening in Berlin at the place where we always drank, ate, gossiped, and desired. Where we still do. However, that evening it was clear that the warmth I had felt on my skin just a few hours earlier was beginning to dissipate fast; that with darkness cold would also come. You lent me your leather jacket, silly gay boy unaware of the ways of moving from day to night in a city not of his own. For someone who grew up in a small town, dreaming of wasting time by losing oneself in the big city— in the cacophony of bodies, paces, architectures—it still strikes me that sometimes, after all these years of being a small-town boy being carried on by the rhythms of the cityscape, I still have little clue of how to rein it all in. Of how to keep the city in check.

I never understood the concept of effortlessness. I've been told to perform effortlessly. Look effortless. Light. Precise in my movements. Find my light, but not look for it. Know my timing, without having to count. Dance as if my body floats. Cruise as if I am not dying for it. This flesh I carry with me is a luxuriance of material that moves in its own time. A collaborative material. A heavy material. A material of undeniable

Time 51

labor, of effort. Soft. Untenable. Excited, this flesh is poly-temporal. It makes me submit to unstructured time. A lexicon of codes, forming a bodily language of need and belonging without words. A productive excess. An offering and a taking. A thing of its own. A leaky body. A material I am forced to collaborate with. Flesh is blood, fat, and unknown particles. It is cellular. Woundable. Healable. And then woundable again. It is consensually marked. It is nonconsensually marked. Abundant. Unclear. Untenable. Unruly. It confuses me. I have a lot of it.

Some of the fondest memories I have from my late teens and early twenties, having moved from the countryside to Lisbon to start university, are memories of cruising. Of stopping at highway service areas and train stations to cruise for sex in public toilets—a bit old-school considering it was the early 2000s, don't you think? And of cruising the streets of the city in the early hours of the morning after leaving some gay club. I remember walking aimlessly through the cobbled streets of Lisbon, the early morning sun caressing my skin dirty with dry sweat, dust, and the memories of those who had touched me and whom I had touched in return that night. One of the thoughts that would always pop into my mind in those early hours of a bright Atlantic morning was the realization of the coexistence in space of disjointed temporalities. I remember, for instance, sitting with a friend on a bench by a large Lisbon boulevard, at the bottom of a park that was then infamous for gay sex trade, and watching people walk to the metro station on their way to work. To me such vision had always been somewhat uncanny, even sublime. There we were—my friend and I—sitting on a bench smoking a cigarette at the end of our night while watching people going about their life in their morning. "We're looking at the future," I used to say, "We're here

tonight looking at their tomorrow!" Strange temporal metaphysics, filling my mind with wonder.

I imagine being touched as a series of small ruptures that convert heat from water into air. Translucent thresholds and traces. I am a mound. An unmovable boulder. My belly is a third genital. . . . Flesh is another genital. However, this flesh is unpredictable. Unnerving.

I fuck you with my flesh. I fuck your time.
I fuck your duration. I fuck your continuance.
I fuck your infinity. I fuck your tide. I fuck your juncture.
I fuck your measure. I fuck your units. I fuck your seconds.
I fuck your tempos. Your allotments. Your spans and
 stretches.
I fuck your stints. Your chronology. Your lifespan.
I fuck your eternity. I fuck all your crannies.
All your slits and crevices. I fuck your fissures so wide,
that we can't measure time,
and I am ruined in every direction.

The city always had that appeal to me, the appeal of the many temporalities that cut across our bodies as we move through it. My fascination with the city wasn't, however, necessarily the same as the fascination that animated the flâneur in Baudelaire. Yes, we both found ways to "distil the eternal from the transitory" in our fleeting, ephemeral meanderings through the city.[1] Yet, Baudelaire's flâneur always felt too heteropatriarchal, too rigid, too bourgeois, too coded in his apparent abandonment to the lure of modern urban life. I was a cruiser, not a flâneur. What I loved doing was cruising, not flânerie. The difference to me was always one to do with time. Indeed, Baudelaire's flâneur wanted to distill for himself the essence of modernity, but to me it was

Time 53

never about finding the essence of anything. Instead, it was about delving into ephemeral constellations, into chance encounters, crossings of one body with another, the beauty of those fleeting moments when two life stories, two life paths cross each other, each with their own rhythms like my friend and I smoking a cigarette on that bench at night while others took the morning metro. The folding of time upon itself in a beautiful supernova. And the possibility that our eyes would still meet one another, maybe a glance, a smile, an invitation to lose ourselves in each other's bodies, at least the exchange of a phone number before our paths would split, carrying with them the memory of what we had briefly been together. My today, your tomorrow, an orgasm across time.

I've gotten really into edging. I jerk off until I can't stand it, and then pull out right before I cum. I calm myself down with a few slaps on my crotch and then get back to the day until I cannot stand it anymore. And I do it all again. It becomes a cycle. An energy production. An assembly line. A recharge. I also read that edging is good for strengthening one's immune system. So, I see it as self-care. A way to keep this body strong. To keep this body in transition. In cruising time.

That reminds me of the video you shot at Ficken3000 during the first COVID-19 lockdown in Berlin. Bars and clubs had closed, and you managed to get yourself in that most infamous of gay male cruise bars where you were filmed trembling and breathing heavily as if animated by the ghosts of all the bodies that had, over the years, fucked in that darkroom. Bodies that were no longer present, apart perhaps from the stain on the walls, on the surfaces of the pleather furniture.

The same summer you put your head on my shoulder, I shot a video in the darkroom of one of the oldest cruising

bars in Berlin. At that point, Ficken3000 had been officially closed due to the first lockdown, and I was determined to get in there to feel what an unused cruising space frozen in liminal time felt like. I turned on all the house lights and shot myself in a series of tableaux in which I trembled among the moldy cum-encrusted walls and worn-out glory holes.

Bodies that you nonetheless conjured from the depths of time into the room with you, bodies many of which are certainly no longer with us. The first time I watched *Tremble*, I was completely taken back by the feeling of generosity and care that seemed to animate you and every trembling fold of your body. That sense we queer people have that time is very much of the order of the fleshy, of the carnal. Our bodies are archives that carry the histories of our traumas, of our desires, of our pleasures and joys—of our struggles—with us at all times, anywhere we go. It struck me how it was you—your body—who was able to invoke the ghosts of the bodies of all the men who had temporarily shared that space, who had enjoyed that space and one another in it. Considering how often those spaces of cruising and sexual sociability close

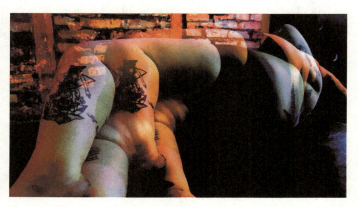

Tremble, HD video, 2022, Liz Rosenfeld, Berlin. Courtesy of the artist.

themselves to you, to bodies like yours, it was truly a thing of beauty and light to see you there, alone, trembling, single-handedly paying tribute to that space and to those histories of desire, pleasure, and communion . . . to those absent presences.

I trembled, my flesh against surfaces frozen in time that felt as if the cruising had been put on pause, not canceled. While activating my flesh, I felt the hollow time of the empty darkroom, like a stretched-out hole. As if time was fossil-ized rather than stopped. As if the pause button was just waiting to be pressed, rather than starting from a beginning. I edged my flesh through trembling. I edged my body towards time. For me, cruising has always been a practice in edging.

How long can I withstand the gaze? How long will I jerk you off before I allow you to touch me? How long do I have to pretend to perform? How long until I perform for real? How long until you realize my dick is not the dick you expected? How long can I hold my breath, my voice, my body until it feels seen? How long until someone asks me what it is I am looking for in a darkroom filled with cis male flesh? How long until I am heckled out of there by twinks in a cir-cle jerk? How long until a bear sees a reflection of their own body in my body? How long until the access and material of my flesh spills into yours? How long until I feel the immea-surable possibilities of cruising time? Of trans time?

How long until enough is never enough is never enough is never enough?

You've always struck me as someone to whom cruising means something else as it mixes and in-forms the flesh of your body. *Tremble* is a living monument to queer kin, to both the ephemerality and the beauty of queer kinship, the cre-ative world-making we engage in whenever we fuck across barriers, across all the overdetermined ways in which we are

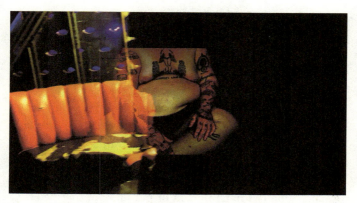

Tremble, HD video, 2022, Liz Rosenfeld, Berlin. Courtesy of the artist.

taught sex, intimacy, and family. *Tremble* is a ruin that challenges the purportedly universal nature of those words—sex, intimacy, family—and what they supposedly exist to name, to bring into being, all the ways in which we have been told some things will forever remain as they are. Challenging all ossified experiences of time according to which the past is gone, and the future is to come, you stayed there in that darkroom waiting, trembling, recalling, remembering, calling forth—calling in—those who had gone and the others yet to come. Your cruising, a syncopated rhythm in the seemingly linear beat of the passing of time, one capable of molding time to the panting of your breath, the folds on your skin. I'm sure, to some, you were wasting time. To me, however, you were making it.

Cruising time is the time of surprise, the time to allow things to be otherwise, to be carried away to unforeseen shores. Cruising time is a particularly queer kind of time. That must be why I never really enjoyed cruising bars or bathhouses that much. The admission ticket, the payment, the opening hours remind me too much of the ticking of

clock time. "Have sex while you can, we close at two," or whatever. Those spaces have always induced some anxiety in me, due to the compulsion to perform, to meet my targets, to count my loads, to be a good boy. It's amazing how the clock time of the factory that inaugurated modernity also eventually took control of most other aspects of our lives, including the moments when we think we are fucking, not working.[2] Clock time has become the frame within which everything else happens. Still, it doesn't have to be like that. We can still create breaches in clock time, we can still refuse to make time the handmaiden of production, of efficiency, of cost-benefit analyses.

Over a Saturday brunch a few years ago, a queer doctor friend of mine casually asked me if I took PrEP and, if I didn't, had I considered it?[3] He knew I had a "cruising life" of some kind but didn't know exactly how I engaged. He knew I was slutty. He knew that, in a perfect exchange, I am someone who prefers to feel seen as having no gender. "I never thought about it," I said. "I never considered that I was even allowed to consider PrEP." "Think about it," he said.

It was the same tone of voice we used regarding how many hours we managed to sleep the previous night, or what we wanted to eat for breakfast. It felt like any other ordinary question, on any other ordinary day. But, for me, I never forgot this brief exchange. I never forgot how time stood still for those thirty seconds of conversation. It was disorienting how deeply seen I felt by my dear friend, who just treated me like any other slutty faggot who brunches, while simultaneously feeling so angry at myself that I was experiencing a moment of validation because a cis gay man asked me casually if I took PrEP, the drug for cis fags. Somehow, I felt a new opening, a new hole dilating slowly in myself. It is still dilating today, all these years later, the space between his

58 Crossings

question and my answer. In most moments where I feel the most seen, I also feel the most disoriented. Surprised. Taken aback. As if in a dream. Or rather, as if I had already lived that moment, thought it, invited it in. Thinking back to his question and my answer, maybe that space I feel—that hole of time—is like a slow burn expanding in me.

A while back I read "Antiretroviral Time." In it, you discuss the experiences of extended temporalities catalyzed by the introduction of antiretroviral drugs for the treatment and prophylaxis of HIV infection.[4] Apart from the radical health changes those drugs brought to those who can and want to access them, a fundamental aspect of their significance for queer cultures is the way they facilitate an expansion or dilation of temporality, both in terms of extending the lives of those living with the virus and in allowing for queer people to engage in new sexual practices without fear of either contracting the virus or infecting someone else. Of these significant aspects, the one that strikes me as the most important is the way that, in gay male sexual subcultures, there has been an increase in eroticization of exchanges of bodily fluids and days-long sessions of sex play, either in private homes or in sex clubs. That reveals how a biomedical technology developed to lengthen the lives of people—and, thus, to increase our longevity as standing reserves of labor and consumer power, allowing us to continue to be productive for longer, doing our part to produce value and sustain the circulation of capital—how that technology has, paradoxically perhaps, also opened a pathway for gay men to engage in behaviors deemed unproductive, to waste time, to play rather than work. This sexual dilation of our experiences of temporality beyond the time of labor, of investments and returns—or, at least, of returns that are as yet to be captured by the apparatus of capital—does resemble

Time 59

another and much older queer experience of temporality: the temporality of cruising.

José Muñoz wrote about how "queerness is not yet here," while the past is "no-longer-conscious" but made instead of "ephemeral traces, flickering illuminations."[5] I feel that . . . He asked me once if my accounts of cruising, included in my MA thesis about time and cruising, were "authentic" or "imagined," asking me if I had indeed experienced all the encounters relayed in my writing, and to state when, how, and where the encounters had taken place. "Does it make a difference?" I asked. "To a certain extent, isn't cruising time—like queer time—about dreaming?" I don't remember what he said next, but I did silently wonder why he wondered. And at the time, I think I was angry. I felt questioned, invalidated. Yet, looking back on that conversation fourteen years later, maybe his questions were his way of cruising me, of cruising my ideas, my process, my time. Doing his job as a queer elder, an overseer, an advisor. Would José have asked me about PrEP, if PrEP were an option back then? Or would he have just assumed that I had no use for it because I was just another queer dyke trying to take up space in fag cruising time, time that was never really meant for me anyway. I like to think he saw me for the fag I was and the fag I was to continue to be and become. I like to look back at that past conversation and only take this exchange as an example of his own words-in-progress, in process, in cruising time, how "the performative force of the gesture interrupts straight time and the temporal strictures it enacts."[6]

Time is not just a thing the body moves through, to paraphrase the title of T. Fleischmann's beautifully erotic autotheoretical book.[7] Time is, instead, very much in the body and of the body. Time makes us. Yet, at the same time, with

60 Crossings

the very same force, time can undo us. At one point in their book, Fleischmann notes the temporality of a particular sexual encounter of their past:

> Aligning our bodies across bodies, reaching and joining, we immediately begin fucking, becoming just the two of us, an orgy of two that lasts for days. Our union is a further splitting open of time, in the way erotic time is composed of infinite moments. It moves me forward like da Vinci's Vitruvian man stays still. We fuck in barns and yards and the backs of trucks, into the night and morning both. I barely see the friends I came to visit. We fuck in the afternoon after napping, and I wake him by first gently kissing his tits, then shoving a Snickers ice cream bar into his mouth and fucking him again. We decide that we love each other. We lie in the sun. We smoke cigarettes. We fuck so much that when we realize we are both headed to New York for the summer, we change our flights so we can fly together and fuck on the airplane.[8]

Fleischmann's story reminds me of a particular detour I once made in New York on my way from London to a conference in Chicago. I had arranged to stay with a fuckbuddy whom I had met a year prior when in Shanghai for another conference. Of course, I knew there would be fucking and uppers, yet my plan had also been to catch up with my favorite places in the city, to go to museums and see some art and all that. Little did I know that that week in New York would very much collapse into a seemingly seamless sexual plateau, one fuck blending into another, perhaps only punctuated by food and toilet breaks: a week condensed into a single memory, a marathon recorded on my mind as if it had been a sprint. Where had time gone?

Time 61

I once wrote Fleischmann a fan letter. I had spent the summer rereading their book over and over again as if it had been cruising me. I devoured it like I had been picked up by my crush in the darkroom. It was a real kinda old-fashioned fan mail of sorts. A love letter to a stranger, from whom I had no expectations. While Fleischmann's gorgeous account of a sexual encounter lasting for days brought to mind similar experiences of my own, I cannot but feel that this was not about our bodies splitting open time but, instead, about our bodies *resonating* with one another at a particularly queer frequency, a particularly queer tempo. Through sex, through queer sex, our bodies came together not *in* time but *as* time, which veered away from the time of things to do and places to be—time of pure expenditure, as Georges Bataille would have it.[9] It is there that I would like to locate the time of cruising in all its queerness. In queerness, just like in cruising, we don't do with time what we're supposed to do. Queerness, like cruising, amplifies different temporal frequencies in our bodies and collapses the linearity of straight time: we seek, we long, we endure, we wait, we dwell, we fantasize, we embody a state of suspension, a plateau of desire that does not always—not necessarily, perhaps—resolve into the pleasure sought.

I wrote:

I can't deny, I have a history of writing these letters. It's really become a practice of archiving moments in my life. If memory serves, one of my earliest letters of admiration was to River Phoenix in 1991. I was 11 and had just seen *My Own Private Idaho*. I was lucky enough to grow up in New York City as a fat kid who always looked older than I actually was, and often used this privilege to buy cigarettes, sneak into porn cinemas, and attend R+++

rated films before a legal age. Like many pre-teen queers of that moment, I remember the pain of watching such a familiar desire expressed and projected so profoundly back into me. A language I felt so deeply, but was unable to articulate. I felt so seen and so alone at the same time. And so profoundly moved by the embodiment and experience of hypocritical desire and love, both of which I continue today to strive to untangle in my own work. And both of which, for me, are at the root of queerness.

I don't know if they ever received my letter—well, my email. So, I guess it was a new version of an old form. I never heard back from them. And I was relieved. Some of the most exciting moments of cruising are when you are left alone with your desire, and it produces nothing but time. Time to be with yourself. To look at yourself. To feel yourself. A kind of time we often never allow ourselves to encounter or move through our bodies.

I can't remember when you and I decided that we love each other; it always just was. Between all the cigarettes I insist you roll me, the endless dinners where we talk in circles and maybe try to argue about what we actually agree on, all the holes, the STIs, the anxiety, the instance when suddenly, without question, I was *just* Daddy. We submit to each other without needing to ask permission, and this desire between us continues to propel us—to our delight—without any explicit kind of consensual beginning or end. We never had to decide to love each other because we just did and do. I still remember the time when you told me that you enjoyed going to gay male cruising spots not so much because you were looking "to score," but because you loved to exist in that space of suspended temporality, of the chase, of the lingering; that temporality of looking and of being looked back at

that can oftentimes open up new spaces of possibility, awaken new desires, open up doors to unforeseen encounters, pleasures, and bodily configurations. That can open us up to surprise. Because you know how much I hate ends—as much as I hate beginnings. Constraints. Definitive allotments of time. It's like when you asked who would write my memoirs, and I told you probably no one. I want them to be timeless. Oral. Wet. Anachronistic. Exciting. Gossipy. I want the stories of our lives to cruise through infinite bodies who decide how these stories are told and retold and retold. Because there will never be a question of how we loved each other and in what time. In cruising time. In trans time. In fag time. In the time of our thoughts and of our longings.

I found a new crack in that leather jacket a few weeks ago. One I had never seen before. It was late at night when I noticed it. A small fissure in the seam of the left arm between the shoulder and sleeve. The leather had separated like it had been overused. The lining had herniated through the tear. I had gone out to get a slice of pizza on the corner around midnight after my fuck date had left. As I was taking off my jacket, just before I noticed this new fissure, I was thinking about how this fuck date was not just a fuck date and that I felt an urgency to tell you, specifically you. I was excited to tell you about how time and space had found a way to completely dismantle me. I am always surprised when I am actually able to experience genuine surprise. What are the moments in which the experience of surprise has edged you towards a threshold? To me, the feeling of surprise is like finding a diamond. Or perhaps more like creating a diamond. My fuck date, a young twentysomething trans masculine boy, arrived fully ready to top me. To top Daddy, as we agreed over the cruising app we connected on. As a Daddy who is always longing to be topped, who loves a good challenge, and

64 Crossings

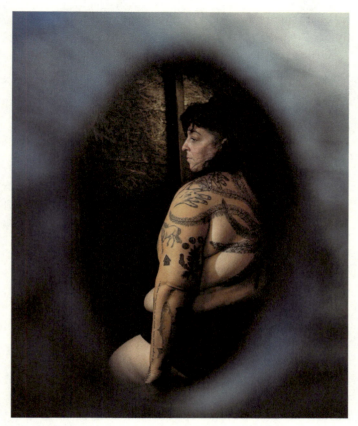

Tremble, HD video, 2022, Liz Rosenfeld, Berlin. Production still by Christa Holka. Courtesy of the artist.

the intersection of how thought waves and fuck waves inform each other, I was expecting this date to be like the others. A fresh-faced trans boy, ten-plus years my junior, eager to please, who tries very hard to tell me what to do, but ultimately crumbles as soon as my fist finds their sweet spot and my fingertips channel the electrical. However, this evening was different.

Time 65

I hate small talk. And I hate to negotiate. I hate to waste time.

Of course, there is a growing tendency for cruising—especially cis gay male cruising—to become driven by the logics of profit and reward, performance and targets, that have marked the encroachment of liberal rationality in our understandings of ourselves, our bodies, and our lives. This is one of the defining features of our neoliberal age, the ways in which it has instituted a completely new form of rationality into our understanding of ourselves. For example, we work hard to play harder; we count every step and add up every calorie towards our targets; we self-manage and maximize our profit and performance through Viagra, steroids, testosterone patches, high-intensity interval training, free weights, etc. Cruising, too, is increasingly being subjected to the economicist temporal logics of working towards a set goal.[10] Namely, by making ourselves the most heroic top or the most enduring bottom; to count our loads as if they were figures on a spreadsheet. To calculate the balances, the cruising grounds becoming our offices, Grindr our fitness app. We play hard to play harder, and we have no time to waste with undesirability, unfamiliarity, or surprise. Jack Parlett writes: "Where cruising in 'real' time and space operates according to the contingencies of encounter, apps serve to regulate the space of cruising and determine users' chosen pathways through it. The incipient and contingent now of a cruising encounter is reified on Grindr as 'Right Now,' the unit of time that delineates a given user's desire for casual sex. The interpersonal immediacy of the street is replaced on Grindr by the vexed evidentiary function of the image, where 'pics'—of faces, torsos, and other body parts—are a primary currency."[11]

"A professional cruiser," I write in many of my profiles. He walked in. We kissed. I felt the need to comment on what

I thought about the terrible lighting of my Airbnb, and how, luckily, it was the right time of year to purchase Xmas lights, so I could create some seedy college dorm room–esque lighting. He didn't really care. I sat down on the bed with a "show me what ya got."

All things notwithstanding, there is an alluring queer perversion to all this working at playing and playing at working. To ride dicks to the rhythm of neoliberal temporality and yet riding them away from the moral principles and work ethics attempting to contain the desire that nonetheless feeds capital and our institutions. After all, both capital and power are, at their core, animated by desire. Capital, like desire, destroys in order to create. "All that is solid melts into air."[12] One thing both the leftist orthodoxy and right-wing conservatives have in common is that they're all scared of sex, because they recognize in sex that very power to both destroy and create anew. While the former wrongly see that power as the main evil of capital, the latter see it, like Faust, as a risk worth taking in the name of profit but only in very specific conditions: the office, the stock market, the investment company, perhaps the toilet seats where lines of coke are often snorted and chased with a glass of whiskey or champagne after a busy week churning out profits.

He asked to unzip my jumpsuit, but—in my mind—it was already unzipped. He played with my tits for a second, but I knew what he had come for. "Your dick," he calls my clit. I prefer "cock." I don't know why. My dick. Your cock. His cock. My clit. The word "dick" never seems, like, enough, and the word "cock" feels almost patriarchal. And yet, I wanna get my "dick" seen and my "cock" worshipped like I want my "pussy" played with and my "cunt" fisted. Is there a way to truly queer these words, or, even in the most entropic moments, is the binary inescapable? One of the most

Time 67

noticeable changes I have gone through since starting HRT is the enormity of my clit. It grew. And it's the one element I can't just casually show off or get cruised. He plays with my dick. He sucks my cock. He plays with my pussy. He fists my cunt. In the break between, I reach over and rub his stomach for a while, redirecting the hair against its organic grain. "It's been a big day for me," I said. "I came out to my folks about hormones today, and you are the first trans masculine person I have fucked since I started taking T." He looked at me so proud, like a Daddy. "That's really big," he said with his sixteen-years-my-junior trans knowledge, "I came out in high school; my folks were pretty cool." My 1.5-years-of-testo brain exploded, while my forty-two years of fleshy body sank under his twenty-six-year-old fist. "I read somewhere that every Daddy needs a Daddy," I moaned under my breath while he edged my clit with his tongue and demanded that Daddy take what Daddy gives until Daddy decides enough is enough.

While this libidinal logic of creation and destruction—of productive destruction—sustains so much of our work lives, modern culture has gone through an immense effort to keep it away from what we know as "private" life, the only place where fucking is—we're told—allowed to happen. This bracketing of the spaces of work and play have, therefore, been a defining feature of our time even though they have consistently blurred into one another.

In her book *Many Splendored Things: Thinking Sex and Play*, Susanna Paasonen takes issue with the separation of play spaces from other realms of life, such as spaces of work.[13] The issue is that the separation of sex from play is ultimately utilitarian. It sees sex as a means of reproduction. Sex—understood in terms of what Lee Edelman called

"reproductive futurism" and José Muñoz described as "straight time"—cannot be conceived as anything else other than labor, albeit labor that will nonetheless have to be carried out in private.[14] Yet, "the overwhelming majority of sexual encounters would in fact fall outside any narrow definitions of purposefulness or usefulness. Sexual play is not necessarily instrumental or productive except for the bodily intensities, thrills and pleasures it offers."[15] Both sex and play are creative endeavors that shape us as we explore our bodies' affordances—that is, what our bodies can do. For that reason, too, neither sex nor play can be easily separated either from ideas of production or from the spaces and temporalities of everyday life. Sex, like play—and like our very own bodies—is porous to the world and to those around us. It is both work and leisure. Yet, it isn't necessarily either of those.

I've always struggled with the compartmentalization of "play space" versus "real space," or even "cruising time" versus "real time." What is "real time" anyway? Whenever I leave the play party or museum, darkroom or dungeon, cruising ground or theater, I often feel sad by the social expectation that the time spent in those spaces is *only* meant for them, and what you take with you from your experiences is to *only* to be unleashed when the "appropriate" time arises again. I like to think of physical encounters as small ruptures. Invisible holes that are portals. Holes that allow new experiences, emotions, potentials to enter. I take these holes with me when I leave these spaces, so I take these spaces with me. These times are absorbed by my body. I do prefer to be in spaces of waiting. I love to wait. I hate to perform. But I love the time after the performance. The time where you are waiting again. The unproductive ambiguity that is produced. The anticipation. It turns me on in all the ways.

Time 69

Cruising time. Performance time. Sex time. Trans time. If you ask me, I say it should be *all* the times all the time. But most importantly, in your own time.

In his book *Macho Sluts*, Pat Califia wrote, "We live in fear of being known, and such fear stifles the nascent erotic wish before the image of what is wished for can be fully formed."[16] The time at which I like to exit is the time in which nothing has been formed yet. I may have come. I may have had a million orgasms. I may have rimmed the holes so deep that they came all over my face. No one may have touched me. I may have just watched. I may have jerked off. But I still have no idea how long it took or who asked for what and when, or what time I started and what time I ended. I prefer it this way.

On my birthday this year I drove out to Dolphin Beach where I had my first cruising experience at age twelve. Crouched in the dunes, up against a small shack, while double-fisting a Snickers and Diet Coke, I watched two bears—in this memory they have always been bears—caress and blow each other among the seagrass and sandy mounds. I can even remember their dicks. The way they held each other's cocks, which fit perfectly in their hands like puzzle pieces, like they had been born into those paws. I studied these men without questions. I kept close watch over their urgency. After they finished and left in opposite directions, I wrote my initials in black Sharpie on the side of the shack, the side that faced the ocean. Twenty-eight years later, those dunes have eroded, and the shack I once leaned up against is just a concrete platform. Sitting among those ruins my memory was triggered, and I had a flashback to the moment when the bears both came at the same time, a choreography that was too perfect. I felt impressed. Jealous. Horny. I felt sad to be among ghosts from so long ago. I missed them . . .

I longed for them in this place that was aging with its own cracks and shadows, just like me. I wondered whether, besides myself and those bears, anyone else knew that this was *the* cruising spot? Who else fucked here? Waited with open-ended desire in the fissures of these dunes? Occupied this space with no expectations? With no goals? Who waited around the entire day with promises of nothing? Who was met and filled to the brim? Whose holes were satisfied? Whose gazes were caught? And then I imagined it could have been you fucking on that beach.

Your reminiscing about the two bears twenty-eight years after you returned to the beach where you saw them fucking—your first encounter with cruising—brings to mind Paasonen's claim that sex play is more of a "magic circuit," one that activates connections, that modulates and amplifies affects across the space of bodies and the weaved temporalities of their lives.[17] The time and tempo of their fucking, the time and tempo of your watching them when you were twelve, of your recalling them in that very same space but in a completely different time. The time that connected the aging of Dolphin Beach, the absent presence of the two bears, the aging of your own body, and your invocation of my presence in that space where I have never found myself. The temporal circuitry of cruising is inseparable from the temporal circuitry of a "longing that propels us onward," to use Muñoz's words.[18]

You could be the next cruiser. Perhaps you were in that moment. You were, through me. Running our flesh across this debris, these lines of time. What are the fissures of these kinds of time? The slit up the shaft of my clit, as it grows with no goal through my transition, which also has no goal. The lines in our bodies, as we age. The scars we accumulate, both visible and opaque. The brief brush of skin on skin we

might remember in the darkroom, on the bus, or in a crowd, when you and I hug goodbye. The various virtual realities we write as we inhabit them. The scratches in time we are unable to articulate yet are always engaged with.

Our admiration and desire.

Your fissures on my leather.

Cruising opens us queers a delicious portal to time. Cruising teaches us to endure time. Between the beats of disco, house, or techno in the club and the dilated temporality of seeking, longing, and waiting that defines cruising, queers are first and foremost defined by the bent time that shapes our bodies, that animates our desires.[19]

Someone once told me about the time when they played Philip Glass during a fisting night at Berlin's Lab.oratory. Apparently, some of the queens got so overwhelmed and taken aback, they didn't know what to do with their hands. I don't get their reaction. After all, the temporal dilation of Glass's harmonic progressions would—I assume—have perfectly resonated with the many bodies in the room.

Cruising time. Fisting time. Expanded minimalist time. Eternal motion of the present. Folded time. Queer time. Fractals. Like edging, they all involve expansion and production without climactic resolution or the need for a scripted future anterior. They are embodiments of time as a vector, a vehicle to cross thresholds.

3

Matter

"Can I hold it," they asked. "Hold it? Sure, I guess. Sure."
"It's so wet." It kept slipping through their fingers and hands.
They couldn't get a grip. I had just been fucked under the
dining room table. We had rolled across the small passage-
way until we hit the backside of the sofa. They got up and
stood over me, rubbed their clit until they squirted all over
my body. Until I stopped demanding. I wanted to shower in
their cum. In their piss. In whatever fluids their hole would
produce. Midway through standing up, on my hands and
knees, I mopped the floor with my then long mane-like hair.
I didn't want to waste a drop. I needed to absorb it all. Into
all the holes. Approaching the sofa, fluid is dripping from
my stomach. I think about how my stomach is a third geni-
tal. If I am standing up, to access my other holes you must
lift it up. If I am laying down, my fat moves backwards . . .
towards my face. I love nothing more than to feel like a
mound of erotic potential. Material to use. It hangs long and
heavy. Powerful. Like a medal. Like a prize. It's unavoid-
able—if you want to fuck me, you have to engage with it.
"Fuck!" They move their hairless pussy and tiny body in
humping motion and grunts. Like the dry humping urgency

of puberty. In heat. I feel them trying to hang on to the edges. Their hands slipping through their slickness. The edges are a little red, scratched. Their attempts feel good. I want them to keep trying.

Attempts. Repetition. Mess. They are all my foreplay. I'm often much happier when something is attempted with obsessive consistency and yet nothing arrives. Like in a cruising space, sometimes no encounter is so much more satisfying than all the encounters. I like to watch. I even like to be ignored. Like anyone and everyone, it depends on the day, depends on my mood.

I watch them try to figure it out. Grabbing the material is just not working. But the commitment to their gestures is just making me so hot. A fist forms following a forearm that slips under the fold between my pelvis and pussy. An edge of fat meets their elbow. They are figuring out the material. How to use it. Maybe how to even control it for a second. The other arm joins. Fist joins fist. And my stomach is held.

On March 12, 1969, almost one year after students and workers had come together on the streets of Paris to fight bourgeois institutions and their morality—to imagine a new world together—psychoanalytic theorist Jacques Lacan told the students at his seminar that there is no sexual relation ("il n'y a pas de rapport sexuel").[1] In sex, Lacan tells us, the other as object of desire remains unknown because our true desire is for something else—for what he calls, after Freud, "the Thing." That is, something totally Other—something totally Real—that we desire but cannot have because having it would end our existence. Only desire fuels life and thus any actual satisfaction of desire would also put an end to life. It is for that reason that Lacan told his students that there is no sexual relation in the context of a seminar about

sublimation. That is, every sexual relation involves a representation—in the form of the body of the sexual partner, the sexual behaviors, the fetish objects—that functions as a temporary, always unsuccessful, stand-in for that which we truly desire but cannot have for our own sake. Therefore, for Lacan, the sexual relation *is not*, because in sex we sublimate the desire for what we can't have but truly want into a desire for something else we don't *really* want but can have. In that sense, there is no sexual relation because, when we fuck, we are always ultimately fucking the representations within our mind that replace that which was repressed but that nonetheless we want. There is no sexual relation in the sense that there is no relation between myself and the one I fuck, only a relation between myself and the phantasms in my mind. That is to say, there is only solipsism, a relation between myself and I. For Lacan, we always come alone.

Years ago, when I was living in London for the summer, I made it my mission to find an infamous cruising spot, the "fuck tree," located in the shallow depths of Hampstead Heath. The fuck tree is famous. I had been meeting and learning about how this tree had held cruising space for decades upon decades. The oldest person I met who told me about the fuck tree was ninety and was accompanied by his caretaker once a week to the fuck tree to "just watch," he said. "I feel as though the tree remembers me. I like to think the tree knows my body after all these years. How it breathes. How it moves. How it has changed," he said in a big exhale. I watched him get up and noticed how his pace and breath were beautifully in sync, like the kind of dance I wish I could effortlessly perform. "Have you been to the tree?" he asked. After being brought to the fuck tree by my friend, my first solo venture was quite . . . dramatic. "Hot?!" he asked me. "Not exactly."

Matter 75

When I was a professional chef, I would bring 10–15-kilo bags of flour up from the dry storage. Sometimes I would lay on the hard concrete floor and put the bag of flour on top of me and wonder if that was what it felt like when I laid on top of someone. Similarly, I wondered this when I first laid on the horizontal elongated trunk of the fuck tree. I felt it hold me. Astonished, I thought about how I couldn't remember another experience where a living thing held me so effortlessly. I have only ever felt this strong and weightless in water. How does the fuck tree feel? Its smooth used bark might indicate that it's tired of holding decades of bodies. I felt like I was floating, levitating. Sturdy enough to be opened, manipulated around, kneaded and consumed. It felt ergonomic even. The usual daily pains of creeping middle age seemed to vanish. This matter felt totally supported.

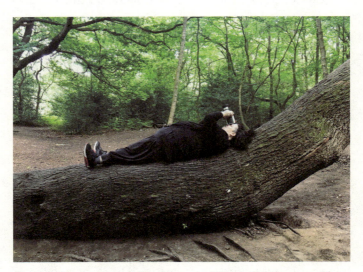

The Artist Lays on the Fuck Tree, Hampstead Heath, London, 2017. Photo by Alex Eisenberg. Courtesy of the artist.

Responding to Lacan's claim that "there is no sexual relation," Jean-Luc Nancy, in *Corpus II*, describes that "foundational" tenet of Lacanian psychoanalytical theory as the thesis that "I am kissed every time I kiss, fucked every time I fuck."[2] Yet, he takes issue with that most Lacanian of statements. For Nancy—and etymologically— "relation" (*rapport*) "[has] to do with 'revenue,' or 'giving an account' or 'narrative,' 'convention' or 'conformity'."[3] The French word *rapport* is also the French word for "report." It is from those meanings that "sexual relation" later emerged as a term. The issue at the center of the Lacanian dictum, according to Nancy, is that a sexual relation is not a thing of which one can give an account, a narrative, or establish a convention. For "the sexual does not relate anything," in the sense not only of putting two things into relation but also of conveying something to us, of reporting on it. The sexual relation is, instead, "not a being, it takes place between beings."[4] Nancy continues:

> A relation is therefore always of the order of the . . . incorporeal, which is also the . . . condition of sense. We can take it up again here as the distinction between bodies. If bodies were not distinct from one another, they would not be bodies, just an undifferentiated, unformed mass. If they are distinct, it must be in the double sense of their being separate and the separation being what permits them to relate to one another. The one distinguishes the other in all senses: one perceives the other, chooses him, honors him. It follows that relation is not in any way a being: it is not anything distinct, but rather distinction itself. Or more accurately, it is the *distinguishing oneself* in which the distinct comes into its own, and it does so only in relation to others, which are also distinct.[5]

"Fuck. I like it," they keep saying. I can feel their arms shaking a bit under my fat. "The weight is so hot. So hot. I need to fuck it again." Their eyes roll back, and their head starts to turn from side to side. One arm slips out, while my stomach spills over the other. I've dried off a bit now and my flesh is less slick. It's sticky. Tacky. They can grab and knead with more ease now. "I'm gonna cum. Shit. It's gonna happen. Are you okay just to keep standing right there? Don't move," while holding on to the sides of my fat as their reins. Sure I am. My gut is a pussy. It's the other hole. An endless ripple. And in this particular moment, the ride of your life.

One of the reasons I am so invested in gay pig subcultures—and one of the things I learned from the various men I have spoken with and learned from, is that, unlike other extant gay sexual taxonomies like the bear, the otter, and the bull, the pig is a highly volatile and shapeshifting category that only comes into being through the sex he has and in the moment of having it. Rather than being, the pig *becomes*. Or, rather, "A pig is what a pig does."[6] Just like with Nancy's reading of the Lacanian dictum that there is no sexual relation, in gay pig sex there is also no sexual relation because the pigs don't preexist the sex they have in order to be put into relation by it. Rather, it is sex itself—a practice of distinction—that creates the pig, that makes him come into his own. The relation does not report back because there was nothing there to report, to give an account of. Instead, my shattered hole, my pighole is a function of the sexual relation not as reporting but as differencing. It comes into being through its being fucked. Nancy again:

> For every living sexual being and in all regards, sex is the being's differing from itself, differing understood as differentiating itself according to multiple measures and

according to all those tangled processes that go by the names *masculine/feminine*, *homo/hetero*, *active/passive*, and so on, and differing understood as the species multiplying indefinitely the singularities of its "representatives."

That is to say, there is no difference of the sexes, but there is, first and always, sex differing and deferring itself. And sex differing and deferring itself must be thought simply as relation, that is, not as being in relation to this or that (for example, in relation to another sex) but as relation itself, that is, as "relating oneself," that is, once again, the opening between of the *between* itself, of the "between ourselves," of intimacy.[7]

In his 2002 short film *Hard Fat*, Frederick Moffet interviews Rick, a gay man who enters the world of "gainers" because he is turned on by inhabiting a large body. Gainers are folks who strive to put on as much weight as possible, as the transformation of getting fatter is an erotic goal. Through

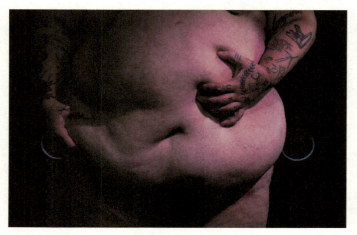

Tremble, HD video, 2022, Liz Rosenfeld, Berlin. Production still by Christa Holka. Courtesy of the artist.

Matter 79

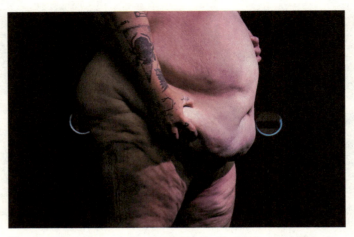

Tremble, HD video, 2022, Liz Rosenfeld, Berlin. Production still by Christa Holka. Courtesy of the artist.

the cruising gaze of the camera, it becomes clear that Moffett is also learning about his attraction to fat men and what this means as a transformation of cis gay male desire. He doesn't just observe and listen to Rick's story, he objectifies him through his horny gaze, creating a steamy energy between subject and filmmaker. Both Moffet and Rick are on their own journeys, cruising through their shared desire, one as gainer and one as admirer, celebrating how bodily transformation gets us off. The first time I saw the film, it was around the same time I started going cruising and realizing how the materiality of my body informed the way in which I felt erotic in the world. It's the gaze of the camera in *Hard Fat* that excites me. The way one can feel the director cruising, watching Rick as he was. I never felt that fat was a fetish of mine. Rather, acknowledging my fat as sexual matter—a material that I am in constant negotiation and collaboration with—opened my erotic potentiality and made me feel empowered and seen in my body. I always say that I

try to objectify myself before anyone else can objectify me. I allow an audience to look at me, give them permission. I show them what I've got before they have a chance to look away. The matter I house. The matter I work with. The matter of myself.

Simply put, matter is anything that takes up space with both weight and volume. Matter can change form, consistency, size, but it will always be made up of the same substance, particles, material. Karen Barad's thesis concerning the idea of "intra-action" suggests that matter is dependent on both human and nonhuman relations, including sociopolitical architectures and the materiality of the bodies that meet them:

> The very nature of materiality is an entanglement. Matter itself is always already open to, or rather entangled with, the "Other." The intra-actively emergent "parts" of phenomena are constituted. Not only subjects but also objects are permeated through and through with their entangled kin; the other is not just in one's skin, but in one's bones, in one's belly, in one's heart, in one's nucleus, in one's past and future. This is as true for electrons as it is for brittlestars as it is for the differentially constituted human. . . . What is on the other side of the agential cut is not separate from us—agential separability is not individuation. Ethics is therefore not about right response to a radically exterior/ized other, but about responsibility and accountability for the lively relationalities of becoming of which we are a part.[8]

Vibrancy. Buoyancy. Ebullience. Animation. Electrical. The space between the surface of flesh and the surface of nonflesh. That energetic space in between can look tiny and

feel infinite at the same time. Sometimes all I need to do is hover my hand over your genitals with zero contact, and that small space between us makes you come. I strike the air over my pubic hair, and my hardon becomes unbearable. My holes gush. I wipe up the puddle underneath me and wipe my hands off on the edges of fat and flesh. And start again.

It's no secret that size has always been attributed to a patriarchal expectation. A simple convention within heteronormativity. It is acceptable for men to be fat, and unless women are rail-thin, it is the end of their sexual lives as they know it, unless they are happy to be fetishized, a consensual kink. This is not to say that body fascism does not exist in almost every pocket of queer sexuality, because as much as us queers want to "accept," we just don't. Queers refuse to publicly acknowledge that politics in the streets is not the same as desire in the sheets, and that hypocritical desire is key to the engagement and becoming of queerness. Hairy but not fat. Otters. Twinks. Muscles fags, health goths. Skinny bitches who love to talk about body positivity, but who would freak out if they gained an inch. Smooth-skinned angelic fuck boys. Hairless. Fresh-faced—White. Same old, same old. Then, on the other end of the spectrum, there's size fascism. You have to be big enough and hairy enough to pass as a bear. I've always been fat, but never hairy enough.

As a fag who has struggled with my own body image ever since I can remember, the mechanisms of inclusion and exclusion from gay scenes have always fascinated me. It is tough growing up a fag, you know? Fags are the worst, and I can't not want to be one! (Funny that.) The wish to look like one of the normatively desired homos is real, as is the failure to ever be able to do that, to look like that, to be that. It can all get quite neurotic. Then depressing . . . I still get social anxiety in many queer environments, especially in

82 Crossings

those predominantly occupied by gay men, the very group of which I'm supposed to be one.

I mean, don't get me wrong, a lot of this is in my head. Most of it, perhaps.

I became sexually active at the same time as the internet came into my teenage home. Into my dad's computer, to be precise. So cruising, for me, was initially often digital. Back then, there were advantages to that: living in a small rural Portuguese village with the nearest gay bar 150 kilometers away, it's not like I had many choices. But also, early internet cruising was mostly anonymous, happening in chat rooms where sending images would take ages over dial-up connections. And I mean, without smartphones, one would either have to try to take a proto-selfie with a shitty digital camera and then download it to one's computer in order to send it to a potential trick, or one would have to scan an actual printed photo and then send it to the potential trick. The facelessness and disembodiedness suited me, an obese teenage gay boy who used to eat his feelings away and repeatedly failed at that, at tackling his low self-esteem with carbs. What a cycle that was.

Back in the day you'd often meet people without seeing them beforehand. Wild stuff, cruising without a body, right? I guess I was cruising with just "vibes," as they say these days. Considering many of the guys on the other side of the screen were often also straight or closeted, disembodied cruising suited both parties. I guess it was all giving *Love Is Blind* but without the marriage proposals, the counting children, the meeting the parents, or the dramatic breakups at the altar.[9] On television. Back then, it was less about commonplaces like "loving someone for who they are on the inside"— religiously uttered, in *Love Is Blind*, by the always normatively sexy participants in "the experiment." Instead, it was

Matter 83

more about fucking someone for how horny and kinky they are on the inside, which is a lot more honest, if you ask me. That's how we did it—*Sex Is Blind*. Also, there wasn't much to choose from, not yet screens and screens of fleshy matter—of meat—to scroll through and consume, so any protein was as good a protein as any other, at least as far as I was concerned. I guess I was already a socialist at that time.

Growing up gay and sexually omnivorous—I mean, gay and socialist—meant that I would fuck any guy up for it. Still do. That's why the question "What's your type?" always leaves me without an answer. My type? I dunno. I guess I like them breathing and willing. Does growing up feeling undesired—undesirable—mean that you learn to desire everybody? Then again, friends who look like they would have every single fag begging for their dick often also speak of how much they lack confidence about the way they look, about the matter that they are. It's almost as if no matter how solid you are, you will always melt into air. It's almost as if the desired object—in this case, the desired mirror image—is always-already unreachable and yet we force ourselves—and I say "ourselves" because I also include myself in that—to chase it no matter what.

Unlike Rick, the main protagonist of *Hard Fat*, I have always been fat. I was a fat kid, teenager—and now—adult. Being brought up by a mother who stopped men in their tracks because of her conventional beauty and who spent her life counting every calorie, I had to find a way to sexualize and empower myself because no one in my immediate proximity was going to do that for me. Like Moffet, I am also increasingly horny for bodies in transitional states, particularly my own. I will always be a high femme top who started cruising in the backrooms of gay bars, glory hole booths of dirty bookstores, and porn theaters when I was twenty,

84 Crossings

dragged up like a teenage boy. Most of the time I was "caught in the act." I was "found" and thrown out. Today, I am a middle-aged nonbinary masc trans, (assumingly) approached (as in *passing*) as a cis man in cruising spots. I am still fat. But the fat has changed. It moved. Migrated. I used to have hips, and now my arms hang more linearly. I can feel it. Now I have a belly that extends out, instead of down. But I am still both high femme and trans fag. That never changed. And my belly is my most empowered sex appendage. That also hasn't changed. It's a shield and a fuck toy. It's a mound consisting of thousands of fuck holes. A sponge. A cushion. It loves to be of use and be used. Cruising helped me to do this, to find this specific relation to this specific material, to understand my personal borders. It continues to do so. I found my erotic matter in relation to erotic space. I enjoy hard edges against soft material. The way cruisers brush up against my body, and I can feel my tummy jiggle a bit when someone tries to get by, or to come close to check me out.

In *Body Fascism*, Brian Pronger draws from Jacques Derrida to try to understand the "logics of parergonality"— that is, the logics of the limit—that sustains fitness technologies and cultures.[10] That is, what kinds of inclusions and exclusions are operated as they frame ideas of the body. As Derrida has shown, the frame is always as much about what it contains as about what it excludes; the frame is always a *framing*. And it is always by attending to what is just left outside, to what supplements the framed, that one can better understand the latter, for the two—the content and that which is peripheral to it—are inseparable from one another; they distinguish themselves against one another.[11] Pronger goes on to conclude that modern fitness technologies are invested in a project of sovereignty sustained by neoliberal ideas of self-mastery, self-governance, self-efficacy, and

their corollary, the horror of abjection, of everything that reminds us of our own decay and formlessness, of our aging, our living towards death. Yet—and this is an important point, I think—Pronger doesn't simply condemn fitness, its technologies and cultures, as some kind of false ideology. There is no "outside" of the world we live in from where we can critique that very world. We are all it, and it is all of us. And nihilism is also not the answer. Instead, Pronger acknowledges the reality of *puissance*—of the power of the body—that fitness technologies harness and mold in particular directions, that they make us aware of. Instead of rejecting the ways in which our bodies are increasingly compelled into particular shapes by technologies at the service of neoliberal ideologies, Pronger proposes the following:

> We need to move, to be embodied, in post-technological ways. As in post-colonialism . . . the "post" of the post-technological is not a time that comes after the technological era, but a way of living within technology that is not limited by it. Post-technological approaches can offer openings for resistance to the technologization of the body from within the technological project. . . . It is a matter of living within body fascism while being less of it. For embodiment, even under fascism, "is not a curse, not an affliction, but the only opportunity we shall be given to learn the poetry of mortal dwelling."[12]

"To learn the poetry of mortal dwelling," one must hack, appropriate, and corrupt the very technologies of one's own subjection. Open your body to infinity by embracing your own flesh as ephemeral and plastic matter that is always decaying as it learns itself, trying to stay alive. Desire

alterity in the other and within yourself, move your body towards it. Fear not the excrement of your putrid existence.

All that said, and even as we celebrate all the ways in which our bodies can be hacked, all the ways in which we can appropriate the technologies of our own subjection—of our own subjectivation—we must never forget that the ways in which we queer ourselves do not stop certain aspects of our own materiality from remaining viscous and dense, difficult for others to cut through. In fact, to queer or hack oneself is often a privilege not everybody can afford. Writing about the production and plasticity of Whiteness in trance parties in Goa, Arun Saldanha argues that racial difference is not static and unchanging but instead emerges "when bodies with certain characteristics become viscous through the ways they connect to their physical and social environment."[13] According to that argument, race is not just something we bring into the room alongside the color of our skin. Rather, it is something that is produced as we interact with others and with the material contexts where we meet. As we move through cruising spaces and become parts of temporary many-headed cruising machines, we must attune ourselves to the density of the spaces we forge, to what sticks and to what freely flows. To what extent do Black and Brown bodies get stuck and stand out against the material background of imperceptible yet sticky Whiteness? What subcultural capital do cruising spaces require and who has access to it? What consumption rituals and codes shape our cruising scenes, what sexual mores, and how may these be coded along axes not only of gender and subcultural attractiveness but also of race and class? What are the material conditions that sustain our fucking? Because, you know, "a preference" is rarely just that. Can we imagine fucking otherwise?

My hips were always a dead giveaway in cruising spots. Stupidly, my hips were how cis men knew I was not a cis man. Once I was approached from behind in a darkroom by a knowing pair of hands. I could tell they knew. They came around my backside, brushing my outer ass cheeks, and continued to run down my midriff, circling outwards towards the edges of where my stomach hangs. It was different back then—my hips held my stomach wider. As the hands continued to rub my tummy, he didn't say much but didn't go for any other body part. I just felt him get hard in his pants against my ass while he outlined and rubbed my stomach in repeated slow motion.

Coincidentally, I got into cruising when I got into art school. The two were not explicitly linked, but both experiences informed and supported each other. *Heart*—that short video consisting of what I imagined a gay bathhouse scene to look like—employs a first-person voiceover, my voice, as I wander through a sauna-esque cruising scene to encounter and go for the young, scared boy who turns me on. Turning to the only references I had for cruising at the time—gay porn and *Queer as Folk*—I top him like what I thought a top was back then.[14] Something *exclusively* brutal and unemotional. Pragmatic. Because that is how gay male sexuality was portrayed in pop culture—unemotional, relentless sex in a cruising scenario. Pragmatic. I am not suggesting that this is no longer the case. But it's certainly not the only case. My extremely young and high-pitched voice—a bit uncertain of itself and its direction—describes the boy I pick up as having "frightened deer eyes," as I flip him over to fuck him while his tits burn on the hot sauna floor. Two things happened after I showed that work in my video production class in art school. One of the cis gay men freaked out and accused me of stealing an experience and infiltrating a space that did

not belong to me. And I met James, who ended up being my partner in cruising, my beard. James was an avid cruiser and showed me the ropes. I asked him to take me to all the cruising spots, and we spent our year together in school doing just that. He hid a camera in a gym bag and filmed only me. I needed to see *only* me. To understand how *my* body moved through space. Wandered. Searched. I didn't need to see anyone else. Fourteen years later, James found those old tapes—yes, *tapes*—and I had them digitized. Back then I had never intended to do anything with that footage. I just wanted to see myself. To decipher what was a performance and what could be a real moment of being with myself. What I learned is that the performance is the most real moment of being with yourself, and that cruising was going to be a long road, one that I am still on. In 2017—from that footage shot fourteen years prior—I made *Liz/James/Stillholes*. I look back on that time, when I was "dragged up" in cruising space, and I see some deep roots of where I now find myself, landing somewhere in the in-between.

I have been "making art" since I was eight years old. I have been alive for almost forty-five. I have been on HRT for three years, L-Thyroxine and a cocktail of others for two years. I have no idea how to quantify my queerness or desire. But I officially started cruising in a named cruising space when I was twenty-two. Not sure why this timeline really matters, because the matters and *matter* of time get lost in the matters and *matter* of the body. My friends tell me the longer I take testosterone, the younger I look. Fat folks, too, are often told they look ageless. When I am sitting in the darkroom, or even the park. It can be the middle of the day, or night. Early morning. Or that weird time of midday that always produces that strange sent-home-from-school feeling. Uncanny time, really. That's what cruising always feels like

to me. And my body, an uncanny time-based material. Yet, as matter, you can't grab and fuck time like you can my flesh. Like you can my hanging fat. But you can sense and feel it around you. Like the darkness. Like the light. The nature. The concrete. The cold tiles. The corner of the club. The smooth bark and solid body of the fuck tree. Like the space of energy between the surface of my palm and the surface of your body. Whatever. Wherever. However you look for it. Whoever finds it. Art is matter, too, I suppose. It's also a desire. And it is also absolutely nothing at all. I mean who cares . . . really? Cruising, at least, produces results; even if it's no result, it's still a result. You show up, you encounter, maybe you come, then you go. You show up, nothing is happening, you go home. You show up, you sit down, you watch, you jerk off. You show up, you find out. Art can't even promise mediocrity, even though that is its status quo. Cruising is both transitional and ephemeral, but it's clear when you are wanted and when you are rejected. It reassures no matter what. Art is just an economy of false hope. Yet, in private, it has helped me understand something physical and emotional about myself, about the people I love and the world I want us to keep creating together. In public, cruising has done the same. The two continue to usher this fleshy material I house, collaborate, and share a body with. That's about all I get for now.

"I have this fantasy. I know it's not very original. But, I'd just love to fuck with you in public. I love how much you get off on it." My partner and I are falling in love. We are falling in lust. We are falling in every way. It's the best clique. And somehow, a year later, sex just keeps expanding. Matter is in constant flux. I have a deep desire. Not a remarkable one, but it makes me really hard and wet to think about. I want to meet you in the darkroom. Encounter a body I have

gotten to know so well and continue to find more about. Surprise turns. Dark folds. Excavating under layers of skin and fat. Finding new ways. It is unusual to meet a body so familiar to you in a cruising space, even one that you have not just fucked casually before but can also recognize in the most intimate of ways. Does this defeat the point of cruising, though? To prearrange a date in a darkroom, with someone you know so well. Someone you—in fact—are also in love with. We have managed a bit of secret nipple play under towels and blankets at the mostly heterosexual sauna. We got a bit "out of hand" naked in a public thermal bath once and we were asked to stop. And I fucked you in a dark corner of a pool, while a straight couple pretended not to watch but we could tell how turned on they were. Not exactly meeting in a cruising space. Not cruising at all.

"But how would we do it? . . . How can we fuck the way we fuck? . . . How can we find things the way that we find things?"

It's true. Darkrooms, parks, toilets, do not necessarily support our physicality—our fucking needs. When thinking about any act of physical exchange, cruising areas are generally supportive of a single kind of physicality, which is cis dick and assholes. Holes. Hard edges. Ridges to hold on to. Sometimes, rails and walls to lean up against. Vertical nature. Vertical architecture. But why does everyone always assume cruising exists only as a direct contact sport? What about watching, jerking yourself off? What about not touching anyone or letting anyone touching you? Cis sex—particularly cis gay sex—is always explained with the expectation of a goal . . . *the* goal. The matter, the material, the potential of cruising also lies in what you want from it. Sometimes all I need is to feel seen and not touched. And sometimes I just want to be treated like the rubber bed that I am perched on,

or the tree that is supporting me. Used like I am nothing and everything at the same time. Just don't recognize me. Don't give me special attention. But then I want to be the one in the middle, on my knees. Like you in that Berlin darkroom that night. Sucking dick. That night we cruised together for the first time. The receptacle. Showing off your knowledge. That's why you have a PhD . . . to serve the needs.

When we fuck at home, I lay on my back and spread my legs. You mount me and push the underside of my belly up to get to my pussy. It hurts in a great way. The way my fat spreads hurts in a new way, a great way. One I have never felt before. It makes me feel aware of how my body is changing, transitioning. Like the excitement of stretching a canvas in preparation for making a new painting. I hold the fat of my pussy open so that my small erect T-dick pushes out. I can feel my knuckles brush your bush while you ride my crotch. You let me know when you are inside me and a combination of knowing how the inside of your pussy feels around my fingers—and focusing hard on my huge clit in your hole—makes me come fast, faster than usual. You adjust and remount, and you fuck my dick until you come into my hole. I always know when you're coming.

It's the same when you fuck me in the ass. I lie on my fours, reach behind my back, and hold a fistful of each ass cheek open, matter protruding through my fingers. My legs are spread, and I can feel the air on my asshole move down past my balls, towards my dick. You get on from the back and your dick fills my ass, expanding well beyond its original shape. Instead of an erection, it feels like an expansion. A reaching-out of matter. We both grow, your meat filling my hole. You always tell me you can feel your dick hitting the depths of my gut. I always tell you I can feel your dick hitting the depths of my gut. And when you come in my ass,

the short-circuit takes me places. It propels me. Or maybe that was the poppers. Maybe it was something else. And we just don't know what to do with all the liquids. All the juices. The pre-cum. The piss. The actual cum. All of it. Sometimes some blood. I want it all. They overflow and drip down towards where my dick is. Matter closing in on matter, matter intra-relating. You fuck my face and call me a good boy. You ask me if I want it. I want all my holes holding all of you—every drop—all at once. I wish so hard it makes me hard. It makes me hungry. I want to please. To feel you in me. My asshole is a circuit box and sometimes you just switch on all the lights.

"How would we fuck the way that we fuck in a darkroom? In a park? In a toilet?" We could reach around and finger each other. Make out. Play with our tits. Finger our assholes. "Assuming cruising space is always cis male space, how would we pass?" How can this be the only element that keeps us

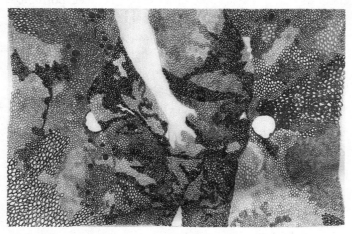

All My Holes #2, drawing, ink and graphite on transparent paper, A3 297×420 mm, 2021, Liz Rosenfeld, Iceland. Courtesy of the artist.

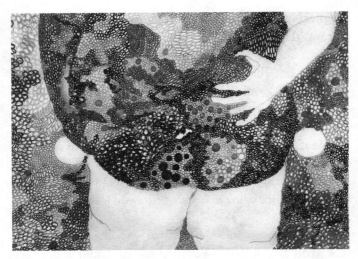

All My Holes #1, drawing, ink and graphite on transparent paper, A3 297×420 mm, 2021, Liz Rosenfeld, Iceland. Courtesy of the artist.

away from fucking together in the darkroom? Paul Preciado suggests that our arm could be a dildo.[15] Tentacle porn proposes the possibility of how one might fuck the other as a nonhuman appendage. Deleuze offers the idea that the fold weaves together space and time, thought and matter.[16] I offer my fat as a form of genitalia. I can stuff it in, and it can get fucked. It trembles and moves and folds and transforms and weaves us together. It is my duet partner. My roommate for life. My bodily measure of time and space. My partner to nurture.

You once wrote about how, in my work, my body "trembles with a potentiality that, while unspeakable, propels it forward towards horizons yet to be known and named." You wrote that "the vibrations of its curves, of its folds, of its fat, of its muscles, of its breath, of its sounds reverberate across the spaces it inhabits and into the bodies

of those of us who witness them in the room, on a screen, on the written page."[17]

And that's just it. You and me. All of them and us. Our friends and lovers. Blood family and queer kin. All the flesh, all the fat. All the bodily everything. We are stuck with each other and with all the encounters, always asking, "So what comes next?"

4

Breath

March 1, 2019. I have thirty minutes until two hundred people pile in to watch me perform *I Live in a House with a Door*. As I warm up, all I can think about is how much I hate to warm up before performing, and even more, I hate to rehearse. Something feels lost when I rehearse, a sense of an urgent unknown. A sense of edging. I don't want to know that it will all unfold perfectly. I don't want to know with certainty that I will hit my marks and land in the light. I don't want to know who will be there watching. The feeling I experience while performing and while cruising is often indistinguishable, like those special thresholds between laughter, orgasm, and breath. I live for the moments when one is indistinguishable from the other. I hate when the light is too bright or just feels wrong in a cruising space, outside or inside . . . When the daylight is just a bit too bright or when eyes adjust to darkness and suddenly you know what someone looks like even if you can't look into their eyes. When features can just about be discerned. Then you feel the breath of the other and you know what that mouth looks like. It's not just a hole anymore, it's a distinguishable mouth.

That performance coincided with the outbreak of COVID-19 in Europe. Looking back, it does feel quite uncanny that, analogously to other pandemics fueled by our desire—by our need—to be intimate with others—to be in others and have others in ourselves—the breath we shared was suddenly potentially lethal. Just like cum and blood, so too shared breath had unexpectedly become present in all our minds as both necessary for life and a means towards death. Of course, when I say "other pandemics" I mean the AIDS pandemic. But I also must make myself clearer. COVID-19 was very different from AIDS, not only clinically but also biopolitically. The cultures of COVID-19 were rather different from the cultures of AIDS, at the very least because SARS-CoV-2 was immediately narrativized as a virus that could get anybody. HIV, on the other hand, had been—and to a certain extent still is—portrayed as a virus engaged in some sort of selective deathly enterprise—a virus with morals!—catching only those who somehow deserved it due to their ungodly ways of being. HIV was, for a moment at least, hoped to separate the human wheat from the subhuman chaff. SARS-CoV-2, on the other hand, was immediately declared a concern of all, a risk to all. And that—our collective risk of death—supposedly strengthened our very experience of a shared humanity, and simultaneously demanded collective responsibility and a public duty of care, or else. During the COVID-19 pandemic, we all became both victims and brave little soldiers. We were all seemingly conscripted to war, to do our bit for ourselves and everybody else, to do our bit for the state, or else. How different it was from the olden days when faggots were just left to die.[1]

Of course, sex and intimacy lie at the center of all that. A virus that gets in you through breathing—that most moral of duties—unites you with others in your human condition.

A virus that gets in you through nonreproductive, queer breeding, cuts a rift between you and the humanity upheld by others. And thus, just like clockwork, we soon started distinguishing between the "good" COVID and the "bad" COVID, depending on whether the contexts in which it had been transmitted were deemed moral or immoral, whether or not the heart of the sick would weigh more than the feather of Ma'at.[2] Were you wearing a mask? Were you going to the supermarket to buy groceries? Were you working at the numerous factories, warehouses, delivery companies, hospitals that kept us all living while locked down? Were you sacrificing yourself for another or were you recklessly pursuing pleasure, physical contact, alternative modes of sociability seen to be excessive and self-indulgent—excessively self-indulgent—by those warrior-cops of biopolitics who felt addressed by the calls to stay home, to keep calm, and to carry on, and who therefore could not grasp the fact that— for some people at least—staying home alone or with violent families could have been anathema precisely to life itself?

I remember the dread I felt—living on my own—when I was instructed to "STAY HOME, SAVE LIVES." The panic attacks, the loneliness, the depression. I remember starting to see a therapist online during my worst months when we were prohibited to share breath, and I remember making the decision that no, I would not be able to survive without the physical proximity of another human, without their touch and their breath mixing in with mine—that whatever the risk was, it could be much worse otherwise. So I resorted to Grindr to cruise for hookups, trying as best as I could to minimize said risk by creating a small pool of more regular casual sex partners. The geography of that small city where I had found myself living during the second lockdown of late 2019 became a little broader and more capacious,

Breath 99

shaped by my desire for others and their desire for me, for my breath. Others, in bigger cities, flocked in hundreds to theretofore dwindling cruising spaces. Old-school ones—forests, public parks. London's Hampstead Heath or Berlin's Hasenheide were suddenly full to the brim, full of queer life, of desire, of sex. And, of course, the cops would show up like they never did at the factories, warehouses, delivery companies that sustained our illusion that staying alone at home was livable, that physical distance was something survivable. And that even though fucking outdoors—cruising like it was 1970—was indeed the way in which promiscuous sex could be safer in the times of COVID-19. To paraphrase the late Douglas Crimp, once again queers had learnt how to have sex in a pandemic. It was because of our promiscuity that we found ways of staying safer.[3]

I don't want to know whom I will encounter and may roll up against. Even if I know, I rarely *know* or see who is actually in the audience. I need them to be anonymous bodies. Bodies who could either unbearably desire me or unequivocally reject me. Bodies that could also feel uncertain. Bodies without an opinion, but rather an agreement that something had just been experienced. Bodies that want to inhale me. Breathe all over me. Take a deep breath in and let out a huge sigh, because they can't stand to watch me anymore, because they are encased—held—maybe even feeling bound by the breath of others around them. In these instances, breath can become the substance that holds bodies in their place, the material that navigates bodies around each other, towards each other. Breath is the erotic potential that may never fully arrive. Zero period, no full stop, an unfillable hole. This makes me horny. It makes me horny in the same way I get horny right before I start a performance, the feeling of not knowing if I am breathing right before I have an orgasm.

"Don't forget to breathe," they say.

It makes me horny like when I just want to watch the orgy and feel the room breathing. Like I might pass out. Uncontrollable sweat. Sticky palms. Almost floating. Breath organizes the room. The theater. The gallery. The urinal. The darkroom. The bedroom. The street. The supermarket. The café. The underground . . . It organizes the internal as well. The emotional. The release. We breathe to get *it* out. Shit. Cum. Piss. Tears. Blood. Pain. Laughter. We breathe to get through . . . to get through generally, I mean. When I jerk off my clit like a dick, I hold my breath in disbelief until it starts to twitch and a series of small breaths that control my orgasm roll out slowly, like smoke dissipating, because I still can't believe this is *my* body. When my stepchild rested between the legs of my best friend before they cut the umbilical cord, the room was tense—we were all holding our breath. What must have been a matter of seconds felt like an eternity until the midwife confirmed that the baby was breathing. When my mother was in her last hours, I watched her body breathing for eternal moments after they took her off life support. A body that was working hard to let go.

In *Blackpentecostal Breath*, Ashon Crawley writes that "air is an object held in common, an object that we come to know through a collective participation within it as it enters and exits flesh."[4] For Luce Irigaray, air was the forgotten element in the patriarchal history of philosophy—air moves and makes the body living flesh and this fact unsettles phallologocentrism and its privileging of things that stay the same, that stay static, soulless, and unchanging. Heidegger liked earth; Irigaray preferred air.[5] Leo Bersani, too, considered air, inspired and expired the moment we are born and severed from the womb, to be the first moment when a life becomes what it will forever be, a lifelong repetition of

absorptions and excretions—breathing in and out, eating and shitting, being penetrated by a penis/dildo/sex toy that will always never stay, that will always have to eventually pull out. The first inspiration of air being the first moment in which the body reveals itself in its "inescapable receptivity, a taking in which is inseparable from a letting out."[6] God creates life by breathing spirit into flesh, the Bible tells us. Apparently that's the same spirit that animates the rest of the world, which makes me think that the air that I breathe, the air that I blow into your mouth, the air that you blow back into mine, is of the same nature of that which animates the trees against which we have fucked, that which animates the walls of the many darkrooms where we've been willing to share so much with total strangers.

Thinking back to that time—not long ago—when you watched me blow someone in a darkroom in Berlin, I would like to think I was blowing my spirit into his flesh only for him to give it back to me transubstantiated into white, viscous, ejaculate—some kind of divine queer alchemy. A rabbit-out-of-the-hat kind of moment that even the best magicians can only dream of.

I am given a ten-minute sign until the audience will be let in. I am told that it will be quite tight in the room. "People will have to sit on the floor," they say. They will have to be crammed in. I continue to open my lungs and practice my breath. This performance is quite physical. I breathe deeply across different scores, allowing my body to dance in submission to my breath. I slowly unveil my naked body and dance with my own flesh—manipulating, sculpting, and carrying my fat as my breath shows off and moves it, moving my heavy fat. When I hear the word "crammed," I think about a tin of sardines, packed tightly ass to face. A final rush to the glory holes right before the house lights go on in the

darkroom. I think about people cramming their bodies into a space because they need to be the first one who arrives somewhere. Find the best tree. The right shrub. The dark corner that is visible but also hidden. The first one to sit down. The first to get *the* thing, the thing they don't even know if they really want in the first place, but they gotta have it. The first to win. The first and last to be desired at the end of the night. Being crammed in makes me think of heavy breaths. Of losing your breath. Getting the breath knocked out of you. It is a remarkable experience to feel weight holding down—almost restraining—my breathing, because I always assume I am the heaviest body in the room.

I was twenty the first time I got fucked in a darkroom. A silver fox butch dyke Daddy, probably the same age I am now, observed I had just been quietly watching people fuck and play. "I've noticed that you have been hiding solo in the shadows all night," she said as she approached me. "Lemme get a better look at you." She pulled me out of the corner, and just knew.

"Can I touch your neck?"
"I am going to touch your neck."

"Can I touch your hair?"
"You can say harder if you want."

"I might just do everything except kiss you. And all you have
 to say is stop, and I will stop."
"Do you understand?"

Long breath in. Long breath out. Eight counts. I think eight. Sometimes I try to keep count, but really, what's the point? I must feel as much as I have to breathe. I have trained

myself to breathe through my asshole, a tantric exercise I learned through YouTube videos. This technique has become the root of my performance and I have practiced for months, at volumes, in my bedroom. Into my lovers' pussies and armpits. In airplane toilets. Department store dressing rooms. Quietly on the subway. At bus stops and even sometimes in cafés when I am pretending to work. I am training myself to breathe loudly and softly. To breathe as if I am simultaneously made of stardust and heavy latex. When I breathe through my anus, I feel it opening and closing like another kind of mouth. When someone sits on my face, my anus breathes in time with my tongue penetrating their ass. I feel their hole breathing in time with my hole. The anus is often referred to as another pussy, but I think of it as another mouth—I eat it. Devour it. Breathe in and out of it. Sometimes I fantasize that my face is permanently implanted in another person's asshole, and that asshole is my only source of oxygen.

Paul Preciado writes about "dildotectonics" in *Countersexual Manifesto*. He sees the dildo as a tool in the deconstruction of heterosexuality as nature. It is also through the discovery—or, perhaps better, through the production—of any object, including any body part, as always-already a dildo that one can identify and locate sites of resistance and "moments of rupture in the body-pleasure-profit-body chain of production within straight and queer sex cultures."[7] But, you know, what if denaturalizing the penis as dildo could indeed deconstruct sexuality yet only embracing the body as receptive hole had the power to create something new? What if the body as receptive hole—the body as breathing, inspiring hole—could inspire the flesh into new horizons of becoming?[8] What if the hole, as both source of breath and receiver of breath, could take us beyond all the never-ending paranoid

deconstructions of the phallus? Imagine if Galileo's telescope was not a prosthetic phallus—a dildo wishing to fuck the stars—but instead a hole receptive to light from the heavens. "Eppure respira [Yet it breathes]," he would have said.

I am one big hole. I can feel the audience eagerly gazing behind me as I slowly begin to slide off my white T-shirt and reveal my back. I am gaping. The breath begins heavy and in slow motion, as if the wind has just been knocked out of me. They tell you the point is to relax your holes—all your holes. To move slow. To feel them opening. I think there are seven, but that feels too few. Too insignificant. Apparently, we have nine "obvious holes." Some people say it's gendered. That "females" have one more hole than "males." I count nine when I release my breath . . . not sure what that means. There are actually over five million holes in the body—Pores. Apertures. Gates. Blind holes. Through holes. And they are all excreting, gasping, leaking, exhaling, absorbing, expelling all the time. Like *all* the time. They are just doing their thing, in a constant state of labor, another horny kind of knowing that keeps me alert. All those millions of corporeal punctures, breaches, ducts, flues, vents, and dents . . . all those tiny holes in all those bodies witnessing me . . . feeling my breath. I am bottomless.

"Yer new," they bend down and whisper in my ear while holding my body up against the wall, my ponytail in one hand. I am on my knees, head down, ass out. My pants and underwear are around my ankles. I feel the air of the darkroom roll across my ass. Their other hand on my lower back, "I can tell by the way you are breathing." They are right. It is the first time I have allowed another person to touch me in a darkroom. "Whatever you do, keep breathing," is whispered in my other ear. "And just remember, all you have to do is say stop, and I'll stop. And if you can't speak, try and

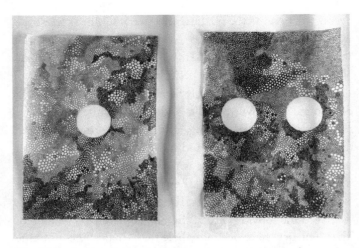

Glory Duet, drawing, ink and graphite on transparent paper, A4 210 × 297 mm, 2021, Liz Rosenfeld, Iceland. Courtesy of the artist.

give me an indication. I will be listening to your breath." My eyes are closed, even though I am facing the wall. A series of hands start to slap my ass. I can feel they are all different. Different touches. Different ways of breathing before I feel skin slap skin. I can sense a big slow breath first before they take a turn. Others come in fast and deep, almost hyperventilating before they touch me. I can almost anticipate the severity of the next impact based on how the breath of the next stranger sounds. I know how good it's going to hurt, or how nervous the person is, or the uncertainty they are feeling, through the shallow breaths I feel on the shelf of my ass. One person gets very close, I can feel their face skimming the surface of my cheeks. Their nostrils breathing in all the hands that had just spanked me, the air produced by the heat of my skin. They stay there, teasing, making me anticipate if the slap will arrive or not. I feel their hot mouth. I feel my red ass getting redder.

I am holding the fat of my stomach, presenting to the audience, showing them how it moves and becomes its own autonomous thing with the intensity of my breath score. I get down on my hands and knees, and it takes the space to hang. As my breath intensifies, I have no control over how my fat moves, it takes its own time. I transition into a slow roll, and roll up against the audience, imagining that I transform into a ball of the erotic, ambiguously indicating some kind of liveness through the way I drum up and control my breath. It's a fine line between panting and hyperventilating. And when I roll up against the audience, and breathe deeply into their body, I feel I am the most charged material.

The gap of breath between the surface of my ass and the nose of the person behind me widens, and I feel them step away. "You're doing a good job," I am told. My long ponytail is wrapped around my eyes like a blindfold, and I am led off my knees and through the darkroom. I am placed with my head down and ass up—on my knees again—on what feels like skin, but I know is rubber, and I get fucked until I come. Hot breath on the nape of my neck this time. "You take my breath away," they whisper in my postorgasmic ear, "you really take my breath away . . . The smart ones are always the sluttiest." I am breathing so hard I can't feel myself breathe. I am coming so hard I can't stop. I am not even sure if I am coming at all.

The breath peaks. As it does. The performance ends. As they do. I always wonder how the hell I am gonna come down from an experience like this. Just like fucking in public, being watched by a room full of strangers is not so different. A vibrance. It is so consuming, you don't know if you can ever come down from it. My lungs. My holes. They are *all* open. FUCK! Anything could slip right in and right out at any moment. An imprint of their fist is left in my pussy,

and my pussy becomes a wind tunnel that you can breathe through. Like a trachea. Like an oxygen mask. When you ride my face and hold on to my nipples like reins, I gasp for air, my clit gets hard. "You take my breath away," an audience member says to me as they approach me after the show. "Literally, I felt my breath leave my body while I watched your breath leave yours . . . maybe they touched." I can't help but think about that cheesy love song, the anthem to every generic airbrushed sex scene from the 1980s. "Who the fuck wants to fuck to this song?" some anonymous queer screamed from underneath a dogpile at a sex party as the song played in the orgy room. It is hard not to laugh. But I like to laugh during sex, it opens things up. You can feel your body differently and, in the best moments, the best laughter edging on hyperventilation can become synonymous with orgasm.

July 29, 2023. At the beach, dancing to a house set by a DJ friend, we met a couple with whom we would eventually have sex by the water further down the forest, just past the formal cruising area but still at listening distance from the stage. Everywhere was a cruising area at that three-day festival where queers of all flavors and persuasions came to dance, fuck, learn, share space and each other—or at least try to. I remember that when you introduced me to them— you had met one of the two a few months earlier at a Berlin sex club—they had just been taking turns breathing into the mouth of their friend, lips locked, breath exiting the one to enter the other and come back again in a circular economy of increasingly carbon-saturated air. "That is ****, my partner. He is teaching our friend how to breathe into each other's mouths. Do you want to try it?" We soon found our lips pressed against one another's, lungs and diaphragms becoming infrastructures for the aerial exchange. We made it last as long as we could bear it, a little longer every single time.

108 Crossings

We made it last until our bodies pulled away, the self reclaiming its space—that is to say, its borders—in an instinctive pull of survival. We made it last until we became high in rarified breath, in the fast-plummeting levels of oxygen in our blood. "Wooooo . . . isn't it amazing? It's better than poppers!" As we breathed again into each other's mouths, I got caught between memories of my own naive teenage breath play with school friends, and the dick that was growing increasingly hard underneath his swim shorts, pressing against my now much older body, as if his dick could deliver me what his lungs were taking away. Something truly special happened at that moment, and I'm sure it was not just about the drugs, the music, the beautiful lakeside atmosphere. It was a sense of his being present to me like nobody else was, of my being present to him like nobody else was.

That feeling, that *knowing*, and the responsibility that comes with the knowledge of another's vulnerability—of their giving of themself to you while you give yourself to them—suggests Emmanuel Lévinas's thoughts on the ethics of breath. Towards the end of his book *Otherwise Than Being*, the French-Lithuanian Jewish philosopher and concentration camp survivor places breath and breathing at the core of his work on ethics, which he famously claimed to be "first philosophy." He describes breathing as "to open oneself as space, to free oneself by breathing from closure in oneself."[9] Breathing, for Lévinas, exposes our innermost core to another who breathes us in. Therefore, breathing—that most important process that affirms us as autonomous individuals—is also, and at the same time, a process through which we open ourselves to the other who breathes in the very air we have expired. By placing breath at the core of ethics and ethics at the core of philosophy, Lévinas tells us that

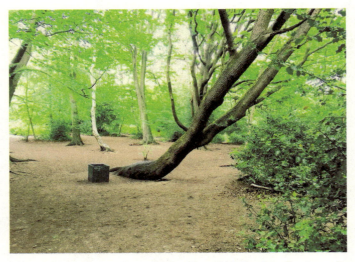

FUCK TREE, Super 8 film, 2017, Liz Rosenfeld, London. Courtesy of the artist.

that which makes us autonomous is also—paradoxically perhaps—that which draws us toward an other we can't ever wholly know but toward whom we have a duty of care, for what makes me one is also what consumes me in the breath of the other. There, on that beautiful afternoon on the beach, we breathed one another and, in so doing, we took each other's breath away only to then give it back so we would never really fully obliterate ourselves. We took each other's breath away in a way that cared about who we both were and who we both could become beyond the collective space of our breathing together.

Alone on an early Tuesday afternoon, I went down to Hampstead Heath's fuck tree to check out the scene. Now knowing where it was, I almost couldn't believe how many times I had gotten so lost looking for it. At a certain point I

thought, "Well, aren't *all* these trees fuck trees?!" But no, there is but one. Its body runs along the ground, as if it is in a state of immutable rest. And at the end of the trunk, it slightly curves up, like a neck with a head, a head straining to reach a source. Maybe a hole. An opening. Perhaps an end point. It always looks thirsty to me. . . . aching to be touched. As I approached the tree, at the edge of the trunk, I slipped on a leaf, or a condom. On a discarded towelette. Who knows? I fell backwards, and got the wind knocked out of me. Stunned, I stood up and clambered my way onto the tree. No one was there at that time of day, except for the occasional yummy-mummy with a yoga mat strapped to her back, pushing a jogging baby pram or walking her dog. Moving small gasps into a slow calm breath, I laid vertically, in line and on top of the tree. As I felt my breath return to a familiar rhythm, I thought, "Trees breathe, just like humans." They take in what they exhale through cells called lenticels that open the otherwise impenetrable bark. The bark of a tree exists as its armor. It protects it against parasites, disease, harm, while letting in air. "The fuck tree literally took your breath away," he replied.

Take my breath away. You take my breath away. It took my breath away. Save your breath. All in the same breath. A breath of fresh air. The breath of life. To gain a second breath. Under one's breath. With bated breath. Don't hold your breath. Take a breath.

My co-star—kneeling in front of me—is fisting me. He was instructed to cruise me in the corridor outside the bathroom and indicate for me to follow. Encountering him against the urinals, I slap him around and call him a good boy. I command him to translate, from French into English, an Hélène Cixous quote about listening but not seeing,

which I had chosen before we started shooting the scene, and scrawled across the bathroom wall in black Sharpie. "It's time to move into the stall when you two are ready," my director friend says from around the corner. The bathroom is so small that she must direct this scene by listening to our bodies, specifically paying attention to our breath. Camera One is above us, shooting from over the top, from the stall next door. Camera Two crouches in a tiny corner to catch a glimpse of us from the outside. She does not watch as she directs, she only listens. A graffitied toilet stall—you know, the usual and the unremarkable. It's dark and small. I straddle the bowl with my legs holding the walls of the stall as if they are glued down, but it's a delicate balance. "Are you comfortable?" the director quietly yells from around the corner. "Just make sure you are comfortable." My co-star stands up for a moment and leans in to check. I can feel how wet his pussy is against my thigh. "Go for it," I say. He reminds me to breathe. Don't forget to breathe. "Don't forget to breathe, I want to hear you breathe," she directs. A fist slips right in, and it doesn't take me long to come. Later, she remarks on the scene, and how heightened her senses were when she had to direct without seeing anything. She focuses on our breath, how it guided her spatially, how she could know what things looked like without having to watch them unfold.

Sometimes in the darkroom, breath is all you can rely on to guide you through the deep darkness. Invisible and binding. Not just a feeling. Not only a sensing. If you focus hard enough, breath creates a map, and the map builds the architecture. In the park, to check in with your breath, it grounds you. Underneath all the bodies, it is a reminder that you can be both an individual and an extension of an other. I go back to Irigaray here: "The breath is a medium, a mediator, which is essential for a becoming of the relation to

ourselves, to the world, to the other." Breath is "both embodied and embodying."[10]

Heaving. Gulping. Huffing. Snorting. Respiring. Wheezing. Palpitating. Gasping Blowing. Ebbing and flowing. Puffing. Throbbing. Winding. Rising and falling. Inflating. Panting and panting and panting. I just want all the panting.

(You know how we often joke that queer academics never actually have the sex they theorize, and that is why they write so much about sex? I think this is a half-truth, though. But when it's brought up as a supporting argument amidst caddy gossip or dirty desire banter, we laugh so hard that inevitably we need to catch our breath every time.)

You took my breath away on a bridge in Venice; my words got lost and fell into the water. You took my breath away while you tried to grab me under the rough current of the ocean and pull me into your tits. You took my breath away in a dream, you restrained me, naked, in front of a full-length mirror. You left me to examine my big hard clit, hairy chest, and face hidden by a full bushy beard as I watched the reflection of your paws slowly wrapping around my neck from behind. You took my breath away for weeks when I had the worst strep throat infection of my life. Amid my fever dreams, I looked up the logistics of how strep is transmitted. I got wet thinking about your respiratory droplets being exhaled into my mouth. It made me feel close to you. This many years later, I still wonder whether it was worth that one single wet, horny, grinding dancefloor snog that absolutely took my breath away, which I liked. And so did everyone else. There are so many sexed-up people who hate to kiss, who hate to be mouth-on-mouth. Mouth-on-mouth is contextual for me. I used to not kiss at all, and then I started kissing everyone. Now, sex can be like a really satisfying handshake—strong and hard, clear. You go in and get

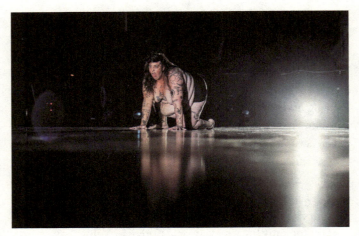

I Live in a House with a Door, performance and mixed media, 2022, Liz Rosenfeld, ANTI—Contemporary Art Festival, Kuopio, Finland. Photo by Akseli Muraja.

what you need done. It's gorgeous and hot. However, more recently, mouth-on-mouth means the person has me hooked hard . . . I am sharing breath. A friend of mine always says he will do it, but kissing is a last resort to getting what he wants. Listening to breath can make me really horny, especially when I do not know who it comes from. Sometimes I record myself breathing when I am sleeping or walking, just to listen what others hear. My lover asks me to send her audio recordings of me jerking off, which mostly consist of breath intensities subtly oscillating. Sometimes I put my ear against different kinds of vibrant matter and imagine breathing patterns. I am attracted to the way people breathe while they talk, and how their breath changes as they walk up hill and back down again.

The more I breathe into you, and you breathe into me, the more I become aware of my own body as I lose myself in you.

It's like I didn't know I had a body—or I did but in such a way that the *knowing* and the body were somewhat kept apart . . . It's like I didn't know I had a body—*my body*—until I felt your breath in me and my breath losing itself in you. You had to take my breath away so I could become my own flesh, which I gifted you.

Acknowledgments

This book is a labor of love, in fact, a love letter between two queer comrades, fellow travelers for life.

We wish to thank our extended community for their unconditional love, insights, and general excitement about this project of ours, for having supported and helped us during the process of writing this work.

Thank you to the ones who dealt with us directly in more ways than one, who believed in us in more ways than one—our elders, mentors, partners, lovers, fellow artists, family of all sorts and friends who got us here: Leah Marojevic, Ben Miller, Richard Hancock, Jesse Katz, Joan and Steve Rosenfeld, Kathy Rosenfeld, Graça and Manuel Florêncio, Christa Holka, R. Justin Hunt, Tracie Farrell, Mikey Ovaska, Sadie Weis, Season Butler, Johanna Linsley, Marit Östberg, Christian Kuellmei, Alina Buch, an*dre neely, Emre Yeşilbaş, Elijah Burgher, James Richards, AA Bronson, Durk Dehner, John Mercer, Jamie Hakim, Susanna Paasonen, Samuel R. Delany, Grace Lavery, Barbara Hammer, Gavin Butt, and Dominic Johnson.

A special thank you to Johanna, who started us.

Notes

Foreword

1. See Michel Foucault, *The History of Sexuality*, vol. 1, *An Introduction*, trans. Robert Hurley (New York: Pantheon Books, 1978); Lauren Berlant, *The Queen of America Goes to Washington: Essays on Sex and Citizenship* (Durham, NC: Duke University Press, 1997); Joan Lubin and Jeanne Vaccaro, "After Sexology," *Social Text* 39, no. 3 (2021): 1–16; and Benjamin Kahan and Greta LaFleur, "How to Do the History of Sexual Science," *GLQ: A Journal of Lesbian and Gay Studies* 29, no. 1 (2023): 1–12.

2. Lauren Berlant and Michal Warner, "Sex in Public," *Critical Inquiry* 24, no. 2 (1998): 547–566. For the citation see Immanuel Kant, *Critique of Practical Reason*, trans. Mary Gregor (Cambridge: Cambridge University Pres, 2015), 99.

3. Michael Warner, *Publics and Counterpublics* (New York: Zone Books, 2005).

4. Tim Dean, "Pornography, Technology, Archive," in *Porn Archives*, ed. Tim Dean, Steven Ruszczycky, and David Squires (Durham, NC: Duke University Press, 2014), 1–26.

5. Wilhelm Jensen, *Gradiva: Ein Pompejanisches Phantasiestück* (Dresden: Verlag von Carl Reissner, 1903).

6. Sigmund Freud, "Delusions and Dreams in Jensen's Gradiva," in *The Standard Edition of the Complete Psychological Works of*

Sigmund Freud, trans. James Strachey (London: The Hogarth Press and the Institute of Psychoanalysis, 1959), 7–95.

Introduction

1. See, for instance, George Chauncey, *Gay New York: Gender, Urban Culture, and the Makings of the Gay Male World, 1890–1940* (New York: Basic Books, 1994); Henning Bech, *When Men Meet: Homosexuality and Modernity* (Cambridge: Polity Press, 1997); Mark Turner, *Backward Glances: Cruising the Queer Streets of New York and London* (London: Reaktion Books, 2003); Robert Aldrich, "Homosexuality and the City: An Historical Overview," *Urban Studies* 41, no. 9 (2004): 1719–1737; Alex Espinoza, *Cruising: An Intimate History of a Radical Pastime* (Los Angeles: Unnamed Press, 2019); and David Getsy, *Queer Behavior: Scott Burton and Performance Art* (Chicago: University of Chicago Press, 2022), 27–28.
2. Chauncey, *Gay New York*, 180.
3. Michael Rocke, *Forbidden Friendships: Homosexuality and Male Culture in Renaissance Florence* (New York: Oxford University Press, 1996), 146.
4. Rocke, *Forbidden Friendships*, 153.
5. Rocke, *Forbidden Friendships*, 153.
6. See Rocke, *Forbidden Friendships*; John Brackett, "The Florentine Onestà and the Control of Prostitution, 1403–1680," *Sixteenth Century Journal* 24, no. 2 (1993): 273–300; and Christopher Chitty, *Sexual Hegemony: Statecraft, Sodomy, and Capital in the Rise of the World System* (Durham, NC: Duke University Press, 2020).
7. Ann Davis, *The Evolution of the Property Relation* (New York: Palgrave Macmillan, 2015), 96.
8. Davis, *Evolution of the Property Relation*, 97.
9. Davis, *Evolution of the Property Relation*, 102.

10. See Jürgen Habermas, *The Structural Transformation of the Public Sphere: An Inquiry into a Category of Bourgeois Society* (Cambridge, MA: MIT Press, 1991).

11. See, for instance, Ann Stoler, *Carnal Knowledge and Imperial Power: Race and the Intimate in Colonial Rule* (Berkeley: University of California Press, 2002); Jasbir Puar, *Terrorist Assemblages: Homonationalism in Queer Times* (Durham, NC: Duke University Press, 2007); Margot Canaday, *The Straight State: Sexuality and Citizenship in Twentieth-Century America* (Princeton, NJ: Princeton University Press, 2009); and Scott Morgensen, *Spaces between Us: Queer Settler Colonialism and Indigenous Decolonization* (Minneapolis: University of Minnesota Press, 2011).

12. See Nancy Fraser, "Rethinking the Public Sphere: A Contribution to the Critique of Actually Existing Democracy," in *Habermas and the Public Sphere*, ed. Craig Calhoun (Cambridge, MA: MIT Press, 1992), 109–142; Lauren Berlant and Michael Warner, "Sex in Public," *Critical Inquiry* 24, no. 2 (1998): 547–566; and Michael Warner, *Publics and Counterpublics* (New York: Zone Books, 2005).

13. Carol Hanisch, "The Personal Is Political," in *Notes from the Second Year: Women's Liberation: Major Writings of the Radical Feminists*, ed. Shulamith Firestone and Anne Koedt (New York: Radical Feminism, 1970), 76–78.

14. Lauren Berlant, *The Female Complaint: The Unfinished Business of Sentimentality in American Culture* (Durham, NC: Duke University Press, 2008), 12.

15. Sarah Schulman, *Conflict Is Not Abuse: Overstating Harm, Community Responsibility, and the Duty of Repair* (Vancouver: Arsenal Pulp Press, 2016).

16. Berlant, *Female Complaint*, 10.

17. Immanuel Kant, "An Answer to the Question: 'What Is Enlightenment?,'" in *Kant: Political Writings*, ed. Hans Siegbert

Reiss (Cambridge: Cambridge University Press, 1991), 54. Emphasis added.

18. Benjamin Shepard, "The Queer/Assimilationist Split: The Suits vs. the Sluts," *Monthly Review* 53, no. 1 (2001): 49–62.

19. See, for instance, Andrew Sullivan, "When Plagues End," *New York Times*, November 10, 1996; Larry Kramer, "Gay Culture, Redefined," *New York Times*, December 12, 1997. See also Douglas Crimp, "How to Have Promiscuity in an Epidemic," *October* 43 (1987): 237–271.

20. See, for instance, Lauren Rowello, "Yes, Kink Belongs at Pride. And I Want My Kids to See It," *Washington Post*, June 29, 2021; Josephine Bartosch, "Tate Criticised for Drag Queen Story Hour Children's Readings," *Unherd*, January 13, 2023; Ellie Silverman, "Montgomery Police to Patrol Drag Story Hours after Proud Boys Protest," *Washington Post*, February 21, 2023; and Oliver Davis and Tim Dean, *Hatred of Sex* (Lincoln: University of Nebraska Press, 2022).

21. Kenneth Plummer, *Intimate Citizenship: Private Decisions and Public Dialogues* (Seattle: University of Washington Press, 2003), 70.

22. Michel de Certeau, *The Practice of Everyday Life* (Berkeley: University of California Press, 1984), 94.

23. De Certeau, *The Practice of Everyday Life*, 93.

24. De Certeau, *The Practice of Everyday Life*, 97–98.

25. Lieven Ameel and Sirpa Tani, "Parkour: Creating Loose Spaces?," *Geografiska Annaler. Series B, Human Geography* 94, no. 1 (2012): 17–30.

26. See, for instance, Sophie Fuggle, "Discourses of Subversion: The Ethics and Aesthetics of Capoeira and Parkour," *Dance Research* 26, No. 2 (2008): 204–222; and Jimena Ortuzar, "Parkour or *l'art du déplacement*: A Kinetic Urban Utopia," *TDR: The Drama Review* 53, no. 3 (2009): 54–66.

27. See, for instance, Laud Humphreys, *Tearoom Trade: Impersonal Sex in Public Places* (Chicago: Aldine Publishing Company, 1970); Martin Levine, *Gay Macho: The Life and Death of the Homosexual Clone* (New York: New York University Press, 1998), 55–76; and Hal Fischer, *Gay Semiotics: A Photographic Study of Visual Coding among Homosexual Men* (Los Angeles: Cherry and Martin, 2015).

28. The various gay lifestyle magazines that started being published from the late 1960s onward with varying degrees of explicit content (e.g., *Drummer, Honcho,* or *Blueboy* in the United States; *Kumpel* or *Du & Ich* in Germany; *Zipper* or *Him* in the United Kingdom) helped disseminate the languages and techniques of cruising. It is also always worth mentioning the classic tongue-in-cheek volume that is George Marshall's *The Beginner's Guide to Cruising* (Washington, DC: Guild Press, 1964), which not only offered helpful advice on how to approach the practice for the first time but did so with a refreshingly campy and playful approach to sex.

29. Michel Foucault, "Of Other Spaces," *Diacritics* 16, no. 1 (1986): 24.

30. See Aaron Lecklider, *Love's Next Meeting: The Forgotten History of Homosexuality and the Left in American Culture* (Oakland: University of California Press, 2021): 17–31. See also Chitty, *Sexual Hegemony*; and Ben Gove, *Cruising Culture: Promiscuity, Desire and American Gay Literature* (Edinburgh: Edinburgh University Press, 2000), 1–40.

31. See Nan Boyd, *Wide-Open Town: A History of Queer San Francisco to 1965* (Berkeley: University of California Press, 2003); Aldrich, "Homosexuality and the City"; and Berlant and Warner, "Sex in Public."

32. Samuel Delany, *Times Square Red, Times Square Blue* (New York: New York University Press, 1999), 193.

33. Dennis Altman, *The Homosexualization of America* (Boston: Beacon Press, 1982), 79–90.

34. Leo Bersani, "Is the Rectum a Grave?," *October* 43 (1987): 206.

35. See João Florêncio, *Bareback Porn, Porous Masculinities, Queer Futures: The Ethics of Becoming-Pig* (London: Routledge, 2020).

36. Guy Hocquenghem, *Gay Liberation after May '68* (Durham, NC: Duke University Press, 2022), 90–92.

37. Hocquenghem, *Gay Liberation after May '68*, xix.

38. Hocquenghem, *Gay Liberation after May '68*, 90.

39. See José Muñoz, *Cruising Utopia: The Then and There of Queer Futurity* (New York: New York University Press, 2009).

40. Lauren Fournier, *Autotheory as Feminist Practice in Art, Writing, and Criticism* (Cambridge, MA: MIT Press, 2021), 2.

41. Jacques Derrida, "Archive Fever: A Freudian Impression," *Diacritics* 25, no. 2 (1995): 17.

42. See Muñoz, *Cruising Utopia*.

Chapter 1 Space

1. Larry Mitchell, *The Faggots and Their Friends between Revolutions* (Ithaca, NY: Calamus Books, 1977), 3.

2. Mitchell, *Faggots and Their Friends*, 8.

3. Mitchell, *Faggots and Their Friends*, 12.

4. Florêncio, *Bareback Porn*, 132.

5. Fiona Anderson, *Cruising the Dead River: David Wojnarowicz and New York's Ruined Waterfront* (Chicago: University of Chicago Press, 2019), 45.

6. See Gayle Rubin, "The Catacombs: A Temple of the Butthole," in *Deviations: A Gayle Rubin Reader* (Durham, NC: Duke University Press, 2011), 224–240.

7. Guillaume Dustan, *Plus fort que moi* (Paris: P.O.L, 1998), 22–23.

8. Eve Kosofsky Sedgwick, "Shame, Theatricality, and Queer Performativity," in *Gay Shame*, ed. David Halperin and Valerie Traub (Chicago: University of Chicago Press, 2009), 50.

9. AMAB stands for "assigned male at birth," while AFAB stands for "assigned female at birth."

10. Michel Foucault, *The History of Sexuality*, vol. 1, *An Introduction*, trans. Robert Hurley (New York: Pantheon Books, 1978), 95.

11. Dick Hebdige, *Subculture: The Meaning of Style* (London: Routledge, 1991), 86.

12. Paulo Freire, *Pedagogy of the Oppressed* (New York: Continuum, 2000), 46.

13. Kathy Acker, "Seeing Gender," *Critical Quarterly* 37, no. 4 (1995): 84.

14. Kathy Acker, "Lust," in *The Seven Deadly Sins*, ed. Alison Fell (London: Serpent's Tail, 1988), 112.

15. Acker, "Lust," 114.

16. Delany, *Times Square Red*, 186–187.

17. Jane Blocker, *Where Is Ana Mendieta? Identity, Performativity, and Exile* (Durham, NC: Duke University Press, 1999), 133.

Chapter 2 Time

1. Charles Baudelaire, "The Painter of Modern Life," in *The Painter of Modern Life and Other Essays*, ed. Jonathan Mayne (London: Phaidon, 1965), 12.

2. See Elizabeth Freeman, *Time Binds: Queer Temporalities, Queer Histories* (Durham, NC: Duke University Press, 2010); and Elizabeth Freeman, *Beside You in Time: Sense Methods and Queer Sociabilities in the American Nineteenth Century* (Durham, NC: Duke University Press, 2019).

3. PrEP, pre-exposure prophylaxis, is an antiretroviral drug regime that prevents HIV-negative individuals from acquiring HIV if exposed to the virus.

4. João Florêncio, "Antiretroviral Time," *Somatechnics* 10, no. 2 (2020): 195–214.

5. Muñoz, *Cruising Utopia*, 1, 28.

6. José Muñoz, "Cruising the Toilet: LeRoi Jones / Amiri Baraka, Radical Black Traditions, and Queer Futurity," *GLQ: A Journal of Lesbian and Gay Studies* 13, nos. 2–3 (2007): 353.

7. T. Fleischmann, *Time Is a Thing the Body Moves Through* (Minneapolis: Coffee House Press, 2019).

8. Fleischmann, *Time Is a Thing*, 18.

9. See Georges Bataille, "The Notion of Expenditure," in *Visions of Excess: Selected Writings, 1927–1939*, ed. Allan Stoekl (Minneapolis: University of Minnesota Press, 1985), 116–129.

10. See Miguel de Beistegui, *The Government of Desire: A Genealogy of the Liberal Subject* (Chicago: University of Chicago Press, 2018).

11. Jack Parlett, *The Poetics of Cruising: Queer Visual Culture from Whitman to Grindr* (Minneapolis: University of Minnesota Press, 2022), 10.

12. Karl Marx and Friedrich Engels, *The Communist Manifesto* (New York: Penguin, 2002), 223; see also Marshall Berman, *All That Is Solid Melts into Air: The Experience of Modernity* (New York: Penguin, 1988).

13. Susanna Paasonen, *Many Splendored Things: Thinking Sex and Play* (London: Goldsmiths Press, 2018), 28.

14. See Lee Edelman, *No Future: Queer Theory and the Death Drive* (Durham, NC: Duke University Press, 2004); and Muñoz, *Cruising Utopia*.

15. Paasonen, *Many Splendored Things*, 28.

16. Pat Califia, *Macho Sluts* (Los Angeles: Alyson Publications, 1988), 9.

17. Paasonen, *Many Splendored Things*, 17–43.

18. Muñoz, *Cruising Utopia*, 1.

19. See João Florêncio, "Drugs, Techno and the Ecstasy of Queer Bodies," *The Sociological Review* 71, no. 4 (2023): 861–880.

Chapter 3 Matter

1. Jacques Lacan, *Le séminaire de Jacques Lacan, Livre XVI: D'un autre à l'autre, 1968–1969* (Paris: Éditions du Seuil, 2006), 226.
2. Jean-Luc Nancy, *Corpus II: Writings on Sexuality*, trans. Anne O'Byrne (New York: Fordham University Press, 2013), 3.
3. Nancy, *Corpus II*, 4.
4. Nancy, *Corpus II*, 6.
5. Nancy, *Corpus II*, 7.
6. Florêncio, *Bareback Porn*, 25.
7. Nancy, *Corpus II*, 11.
8. Karen Barad, *Meeting the Universe Halfway: Quantum Physics and the Entanglement of Matter and Meaning* (Durham, NC: Duke University Press, 2007), 392–393.
9. *Love Is Blind* is a reality TV series that premiered on the streaming platform Netflix in 2020. In it, groups of men and women date each other from separate "pods" where they can hear but never see each other. If they get engaged while in the "pods," they then get to meet each other and live together for a few days before their televised wedding. Getting "engaged, sight unseen" is presented by the show as an "experiment" to test whether "love is truly blind."
10. Brian Pronger, *Body Fascism: Salvation in the Technology of Physical Fitness* (Toronto: University of Toronto Press, 2002), 13.
11. See Jacques Derrida, *The Truth in Painting*, trans. Geoffrey Bennington and Ian McLeod (Chicago: University of Chicago Press, 1987), 37–82.
12. Pronger, *Body Fascism*, 233–234.
13. Arun Saldanha, *Psychedelic White: Goa Trance and the Viscosity of Race* (Minneapolis: University of Minnesota Press, 2007), 9–10.
14. *Queer as Folk* is a 1999 British TV series created by Russel T. Davis, which follows the lives of three gay men living in

Manchester's gay village. A U.S. version was released in 2000 and set in Pittsburg, Pennsylvania.

15. See Paul B. Preciado, *Countersexual Manifesto* (New York: Columbia University Press, 2018).

16. See Gilles Deleuze, *The Fold: Leibniz and the Baroque*, trans. Tom Conley (London: Athlone Press, 1993).

17. João Florêncio, "Trembling the Body into Flight: Liz Rosenfeld's Carnal Horizons," in *Shortlist Live! #4*, ed. Heidi Backström (Kuopio, Finland: ANTI—Contemporary Art Festival, 2022), 25.

Chapter 4 Breath

1. See, for instance, Paula Treichler, *How to Have Theory in an Epidemic: Cultural Chronicles of AIDS* (Durham, NC: Duke University Press, 1999); and Fred Cooper, Luna Dolezal, and Arthur Rose, *COVID-19 and Shame: Political Emotions and Public Health in the UK* (London: Bloomsbury, 2023).

2. Ma'at was the goddess in the Egyptian pantheon that represented law, morality, justice, balance, and truth. In the afterlife, the hearts of the dead (where their soul resided) were weighted against Ma'at's ostrich feather (the measure of truth, order and justice). If the souls had been sinful, the hearts would be heavier than the feather, and the souls permanently destroyed.

3. See Crimp, "How to Have Promiscuity."

4. Ashon Crawley, *Blackpentecostal Breath: The Aesthetics of Possibility* (New York: Fordham University Press, 2017), 36.

5. See Luce Irigaray, *The Forgetting of Air in Martin Heidegger* (London: Athlone Press, 1999).

6. Leo Bersani, *Receptive Bodies* (Chicago: University of Chicago Press, 2018), 85.

7. Preciado, *Countersexual*, 41–42.

8. See Florêncio, *Bareback Porn*.

9. Immanuel Lévinas, *Otherwise Than Being, or Beyond Essence*, trans. Alphonso Lingis (Pittsburgh: Duquesne University Press, 1998), 180.

10. Luce Irigaray, "To Begin with Breathing Anew," in *Breathing with Luce Irigaray*, ed. Emily Holmes and Lenard Škof (London: Bloomsbury, 2013), 217.

Bibliography

Acker, Kathy. "Lust." In *The Seven Deadly Sins*, edited by Alison Fell, 109–139. London: Serpent's Tail, 1988.

Acker, Kathy. "Seeing Gender." *Critical Quarterly* 37, no. 4 (1995): 78–86.

Aldrich, Robert. "Homosexuality and the City: An Historical Overview." *Urban Studies* 41, no. 9 (2004): 1719–1737.

Altman, Dennis. *The Homosexualization of America*. Boston: Beacon Press, 1982.

Ameel, Lieven, and Sirpa Tani. "Parkour: Creating Loose Spaces?" *Geografiska Annaler. Series B, Human Geography* 94, no. 1 (2012): 17–30.

Anderson, Fiona. *Cruising the Dead River: David Wojnarowicz and New York's Ruined Waterfront*. Chicago: University of Chicago Press, 2019.

Barad, Karen. *Meeting the Universe Halfway: Quantum Physics and the Entanglement of Matter and Meaning*. Durham, NC: Duke University Press, 2007.

Bartosch, Josephine. "Tate Criticised for Drag Queen Story Hour Children's Readings." *Unheard*, January 13, 2023. https://unherd.com/thepost/tate-criticised-for-inviting-drag-queen-story-hour-to-childrens-reading/.

Bataille, Georges. "The Notion of Expenditure." In *Visions of Excess: Selected Writings, 1927–1939*, edited by Allan Stoekl, 116–129. Minneapolis: University of Minnesota Press, 1985.

Baudelaire, Charles. "The Painter of Modern Life." In *The Painter of Modern Life and Other Essays*, edited by Jonathan Mayne, 1–40. London: Phaidon, 1965.

Bech, Henning. *When Men Meet: Homosexuality and Modernity.* Cambridge: Polity Press, 1997.

Berlant, Lauren. *The Female Complaint: The Unfinished Business of Sentimentality in American Culture.* Durham, NC: Duke University Press, 2008.

Berlant, Lauren. *The Queen of America Goes to Washington: Essays on Sex and Citizenship.* Durham, NC: Duke University Press, 1997.

Berlant, Lauren, and Michael Warner. "Sex in Public." *Critical Inquiry* 24, no. 2 (1998): 547–566.

Berman, Marshall. *All That Is Solid Melts into Air: The Experience of Modernity.* New York: Penguin, 1988.

Bersani, Leo. "Is the Rectum a Grave?" *October 43* (1987): 197–222.

Bersani, Leo. *Receptive Bodies.* Chicago: University of Chicago Press, 2018.

Blocker, Jane. *Where Is Ana Mendieta? Identity, Performativity, and Exile.* Durham, NC: Duke University Press, 1999.

Boyd, Nan. *Wide-Open Town: A History of Queer San Francisco to 1965.* Berkeley: University of California Press, 2003.

Brackett, John. "The Florentine Onestà and the Control of Prostitution, 1403–1680," *Sixteenth Century Journal* 24, no. 2 (1993): 273–300.

Califia, Pat. *Macho Sluts.* Los Angeles: Alyson Publications, 1988.

Canaday, Margot. *The Straight State: Sexuality and Citizenship in Twentieth-Century America.* Princeton, NJ: Princeton University Press, 2009.

Chauncey, George. *Gay New York: Gender, Urban Culture, and the Makings of the Gay Male World, 1890–1940.* New York: Basic Books, 1994.

Chitty, Christopher. *Sexual Hegemony: Statecraft, Sodomy, and Capital in the Rise of the World System.* Durham, NC: Duke University Press, 2020.

Cooper, Fred, Luna Dolezal, and Arthur Rose. *COVID-19 and Shame: Political Emotions and Public Health in the UK*. London: Bloomsbury, 2023.

Crawley, Ashon. *Blackpentecostal Breath: The Aesthetics of Possibility*. New York: Fordham University Press, 2017.

Crimp, Douglas. "How to Have Promiscuity in an Epidemic." *October* 43 (1987): 237–271.

Davis, Ann. *The Evolution of the Property Relation*. New York: Palgrave Macmillan, 2015.

Davis, Oliver, and Tim Dean. *Hatred of Sex*. Lincoln: University of Nebraska Press, 2022.

Dean, Tim. "Pornography, Technology, Archive." In *Porn Archives*, edited by Tim Dean, Steven Ruszczycky, and David Squires, 1–26. Durham, NC: Duke University Press, 2014.

De Beistegui, Miguel. *The Government of Desire: A Genealogy of the Liberal Subject*. Chicago: University of Chicago Press, 2018.

De Certeau, Michel. *The Practice of Everyday Life*. Berkeley: University of California Press, 1984.

Delany, Samuel. *Times Square Red, Times Square Blue*. New York: New York University Press, 1999.

Deleuze, Gilles. *The Fold: Leibniz and the Baroque*. Translated by Tom Conley. London: Athlone Press, 1993.

Derrida, Jacques. "Archive Fever: A Freudian Impression." *Diacritics* 25, no. 2 (1995): 9–63.

Derrida, Jacques. *The Truth in Painting*. Translated by Geoffrey Bennington and Ian McLeod. Chicago: University of Chicago Press, 1987.

Dustan, Guillaume. *Plus fort que moi*. Paris: P.O.L., 1998.

Edelman, Lee. *No Future: Queer Theory and the Death Drive*. Durham, NC: Duke University Press, 2004.

Espinoza, Alex. *Cruising: An Intimate History of a Radical Pastime*. Los Angeles: Unnamed Press, 2019.

Fischer, Hal. *Gay Semiotics: A Photographic Study of Visual Coding among Homosexual Men*. Los Angeles: Cherry and Martin, 2015.

Fleischmann, T. *Time Is a Thing the Body Moves Through*. Minneapolis: Coffee House Press, 2019.

Florêncio, João. "Antiretroviral Time." *Somatechnics* 10, no. 2 (2020): 195–214.

Florêncio, João. *Bareback Porn, Porous Masculinities, Queer Futures: The Ethics of Becoming-Pig*. London: Routledge, 2020.

Florêncio, João. "Drugs, Techno and the Ecstasy of Queer Bodies." *The Sociological Review* 71, no. 4 (2023): 861–880.

Florêncio, João. "Trembling the Body into Flight: Liz Rosenfeld's Carnal Horizons." In *Shortlist Live! #4*, edited by Heidi Backström, 22–28. Kuopio, Finland: ANTI—Contemporary Art Festival, 2022.

Foucault, Michel. *The History of Sexuality*, vol. 1, *An Introduction*. Translated by Robert Hurley. New York: Pantheon Books, 1978.

Foucault, Michel. "Of Other Spaces." *Diacritics* 16, no. 1 (1986): 22–27.

Fournier, Lauren. *Autotheory as Feminist Practice in Art, Writing, and Criticism*. Cambridge, MA: MIT Press, 2021.

Fraser, Nancy. "Rethinking the Public Sphere: A Contribution to the Critique of Actually Existing Democracy." In *Habermas and the Public Sphere*, edited by Craig Calhoun, 109–142. Cambridge, MA: MIT Press, 1992.

Freeman, Elizabeth. *Beside You in Time: Sense Methods and Queer Sociabilities in the American Nineteenth Century*. Durham, NC: Duke University Press, 2019.

Freeman, Elizabeth. *Time Binds: Queer Temporalities, Queer Histories*. Durham, NC: Duke University Press, 2010.

Freire, Paulo. *Pedagogy of the Oppressed*. New York: Continuum, 2000.

Freud, Sigmund. "Delusions and Dreams in Jensen's Gradiva." In *The Standard Edition of the Complete Psychological Works of*

Sigmund Freud, translated by James Strachey, 7–95. London: The Hogarth Press and the Institute of Psychoanalysis, 1959.

Fuggle, Sophie. "Discourses of Subversion: The Ethics and Aesthetics of Capoeira and Parkour." *Dance Research* 26, no. 2 (2008): 204–222.

Getsy, David. *Queer Behavior: Scott Burton and Performance Art.* Chicago: University of Chicago Press, 2022.

Gove, Ben. *Cruising Culture: Promiscuity, Desire and American Gay Literature.* Edinburgh: Edinburgh University Press, 2000.

Habermas, Jürgen. *The Structural Transformation of the Public Sphere: An Inquiry into a Category of Bourgeois Society.* Cambridge, MA: MIT Press, 1991.

Hanisch, Carol. "The Personal Is Political." In *Notes from the Second Year: Women's Liberation: Major Writings of the Radical Feminists,* edited by Shulamith Firestone and Anne Koedt, 76–78. New York: Radical Feminism, 1970.

Hebdige, Dick. *Subculture: The Meaning of Style.* London: Routledge, 1991.

Hocquenghem, Guy. *Gay Liberation after May '68.* Durham, NC: Duke University Press, 2022.

Humphreys, Laud. *Tearoom Trade: Impersonal Sex in Public Places.* Chicago: Aldine Publishing Company, 1970.

Irigaray, Luce. *The Forgetting of Air in Martin Heidegger.* London: Athlone Press, 1999.

Irigaray, Luce. "To Begin with Breathing Anew." In *Breathing with Luce Irigaray,* edited by Emily Holmes and Lenard Škof, 217–226. London: Bloomsbury, 2013.

Jensen, Wilhelm. *Gradiva: Ein Pompejanisches Phantasiestück.* Dresden: Verlag von Carl Reissner, 1903.

Kahan, Benjamin, and Greta LaFleur. "How to Do the History of Sexual Science." *GLQ: A Journal of Lesbian and Gay Studies* 29, no. 1 (2023): 1–12.

Kant, Immanuel. "An Answer to the Question: 'What Is Enlightenment?'" In *Kant: Political Writings*, edited by Hans Siegbert Reiss, 54–60. Cambridge: Cambridge University Press, 1991.

Kant, Immanuel. *Critique of Practical Reason*. Translated by Mary Gregor. Cambridge: Cambridge University Press, 2015.

Kramer, Larry. "Gay Culture, Redefined." *New York Times*, December 12, 1997. https://archive.nytimes.com/www.nytimes.com/library/national/science/aids/121297sci-aids.html.

Lacan, Jacques. *Le séminaire de Jacques Lacan, Livre XVI: D'un autre à l'autre, 1968–1969*. Paris: Éditions du Seuil, 2006.

Lecklider, Aaron. *Love's Next Meeting: The Forgotten History of Homosexuality and the Left in American Culture*. Oakland: University of California Press, 2021.

Lévinas, Immanuel. *Otherwise Than Being, or Beyond Essence*. Translated by Alphonso Lingis. Pittsburgh: Duquesne University Press, 1998.

Levine, Martin. *Gay Macho: The Life and Death of the Homosexual Clone*. New York: New York University Press, 1998.

Lubin, Joan, and Jean Vaccaro. "After Sexology." *Social Text* 39, no. 3 (2021): 1–16.

Marshall, George. *The Beginner's Guide to Cruising*. Washington, DC: Guild Press, 1964.

Marx, Karl, and Friedrich Engels. *The Communist Manifesto*. New York: Penguin, 2002.

Mitchell, Larry. *The Faggots and Their Friends between Revolutions*. Ithaca, NY: Calamus Books, 1977.

Morgensen, Scott. *Spaces between Us: Queer Settler Colonialism and Indigenous Decolonization*. Minneapolis: University of Minnesota Press, 2011.

Muñoz, José. "Cruising the Toilet: LeRoi Jones / Amiri Baraka, Radical Black Traditions, and Queer Futurity." *GLQ: A Journal of Lesbian and Gay Studies* 13, nos. 2–3 (2007): 353–367.

Muñoz, José. *Cruising Utopia: The Then and There of Queer Futurity.* New York: New York University Press, 2009.

Nancy, Jean-Luc. *Corpus II: Writings on Sexuality.* Translated by Anne O'Byrne. New York: Fordham University Press, 2013.

Ortuzar, Jimena. "Parkour or *l'art du déplacement*: A Kinetic Urban Utopia." *TDR: The Drama Review* 53, no. 3 (2009): 54–66.

Paasonen, Susanna. *Many Splendored Things: Thinking Sex and Play.* London: Goldsmiths Press, 2018.

Parlett, Jack. *The Poetics of Cruising: Queer Visual Culture from Whitman to Grindr.* Minneapolis: University of Minnesota Press, 2022.

Plummer, Kenneth. *Intimate Citizenship: Private Decisions and Public Dialogues.* Seattle: University of Washington Press, 2003.

Preciado, Paul B. *Countersexual Manifesto.* New York: Columbia University Press, 2018.

Pronger, Brian. *Body Fascism: Salvation in the Technology of Physical Fitness.* Toronto: University of Toronto Press, 2002.

Puar, Jasbir. *Terrorist Assemblages: Homonationalism in Queer Times.* Durham, NC: Duke University Press, 2007.

Roke, Michael. *Forbidden Friendships: Homosexuality and Male Culture in Renaissance Florence.* New York: Oxford University Press, 1996.

Rowello, Lauren. "Yes, Kink Belongs at Pride. And I Want My Kids to See It." *Washington Post,* June 29, 2021. https://www.washingtonpost.com/outlook/2021/06/29/pride-month-kink-consent/.

Rubin, Gayle. "The Catacombs: A Temple of the Butthole." In *Deviations: A Gayle Rubin Reader,* 224–240. Durham, NC: Duke University Press, 2011.

Saldanha, Arun. *Psychedelic White: Goa Trance and the Viscosity of Race.* Minneapolis: University of Minnesota Press, 2007.

Schulman, Sarah. *Conflict Is Not Abuse: Overstating Harm, Community Responsibility, and the Duty of Repair.* Vancouver: Arsenal Pulp Press, 2016.

Sedgwick, Eve Kosofsky. "Shame, Theatricality, and Queer Performativity." In *Gay Shame*, edited by David Halperin and Valerie Traub, 49–62. Chicago: University of Chicago Press, 2009.

Shepard, Benjamin. "The Queer/Assimilationist Split." *Monthly Review* 53, no. 1 (2001): 49–62.

Silverman, Ellie. "Montgomery Police to Patrol Drag Story Hours after Proud Boys Protest." *Washington Post*, February 1, 2023. https://www.washingtonpost.com/dc-md-va/2023/02/21/maryland-drag-queen-story-hour-proud-boys/.

Stoler, Ann. *Carnal Knowledge and Imperial Power: Race and the Intimate in Colonial Rule.* Berkeley: University of California Press, 2002.

Sullivan, Andrew. "When Plagues End." *New York Times*, November 10, 1996. https://www.nytimes.com/1996/11/10/magazine/when-plagues-end.html.

Treichler, Paula. *How to Have Theory in an Epidemic: Cultural Chronicles of AIDS.* Durham, NC: Duke University Press, 1999.

Turner, Mark. *Backward Glances: Cruising the Queer Streets of New York and London.* London: Reaktion Books, 2003.

Warner, Michael. *Publics and Counterpublics.* New York: Zone Books, 2005.

About the Authors

JOÃO FLORÊNCIO (HE/HIM) is a professor of gender studies and chair of Sex Media and Sex Cultures at Linköping University, Sweden. A queer cultural scholar of embodiment and sexuality, his research focuses on the interfacing between the body, media technologies, and sex in contemporary culture. Florêncio's work has appeared in *The Sociological Review*, *Sexualities*, *Radical History Review*, *Porn Studies*, *Somatechnics*, and the *Journal of Bodies, Sexualities and Masculinities*, among others. He is on the International Advisory Editorial Board for *Sexualities*, and he is the author of *Bareback Porn, Porous Masculinities, Queer Futures: The Ethics of Becoming-Pig*.

LIZ ROSENFELD (THEY, THEM) is a New York City–born, Berlin-based transdisciplinary artist who works with film/video, performance, drawings, and experimental writing practice. Rosenfeld addresses the sustainability of emotional and political ecologies, cruising methodologies, and past and future histories regarding the ways in which memory is queered. Their work deals with flesh as a nonbinary collaborative material, specifically focusing on the potentiality of physical abundance and excess, approaching questions regarding the responsibility and privilege of

taking up space and how queer ontologies are grounded in variant hypocritical desire(s). Their work has been shown internationally in film festivals, museums, and galleries, and their film *White Sands Crystal Foxes* was nominated for Best Experimental Short Film at the Berlinale's 2022 Teddy Awards. Rosenfeld was also one of the nominated artists for the ANTI—Contemporary Art Festival's 2022 Shortlist Live Award, and their short films are represented by Video Data Bank and LUX Moving Image.

Available titles in the Q+ Public series:

E. G. Crichton, *Matchmaking in the Archive: 19 Conversations with the Dead and 3 Encounters with Ghosts*

Shantel Gabrieal Buggs and Trevor Hoppe, eds., *Unsafe Words: Queering Consent in the #MeToo Era*

Andrew Spieldenner and Jeffrey Escoffier, eds., *A Pill for Promiscuity: Gay Sex in an Age of Pharmaceuticals*

Alexander McClelland and Eric Kostiuk Williams (illus.), *Criminalized Lives: HIV and Legal Violence*

Stephanie Hsu and Ka-Man Tse, eds., *My Race Is My Gender: Portraits of Nonbinary People of Color*

Don Romesburg, *Contested Curriculum: LGBTQ History Goes to School*

João Florêncio and Liz Rosenfeld, *Crossings: Creative Ecologies of Cruising*